New "China"

新瓷

NEW "CHINA"
Porcelain Art from Jingdezhen
1910~2012

新瓷 景德镇的百年瓷艺，1910～2012

Fang Lili
Nancy Selvage

Edited by Willow Weilan Hai Chang

J. May Lee Barrett

China Institute Gallery
China Institute
New York
2012

Distributed by Art Media Resources, Ltd.

The catalogue was published to accompany the exhibition
New "China": Porcelain Art from Jingdezhen, 1910–2012
新瓷：景德镇的百年瓷艺，1910～2012

Presented at

China Institute Gallery

125 East 65th Street
New York, NY 10065
212.744.8181
September 21–December 9, 2012

Library of Congress Control Number: 2012944995
ISBN-10: 0977405486
ISBN-13: 978-0-9774054-8-0

General Editor and Project Director: Willow Weilan Hai Chang
Consulting Editor: J. May Lee Barrett
Catalogue Designer: Peter Lukic
Exhibition Designer: Perry Hu
Printed in the United States of America

Note to the Reader
Chinese is romanized in the *pinyin* system throughout
the text and bibliography except for the names of Chinese
authors writing in Western languages. Chinese terms cited
in Western-language titles remain in their original form
and have not been converted.

Front cover
Top row, left to right: Zhu Legeng, *Zen* (cat. no. 22);
Wang Bu, Brush Pot (cat. no. 14)
Second row, left to right: Zhu Dequn, Vase (cat. no. 40);
Zhao Guozhen, *Sacred Water Buffalo* (cat. no. 19)
Bottom row: Yao Yongkang, *Millennium Baby* (cat. no. 21)

Back cover
Top row, left to right: Caroline Yi Cheng, *Prosperity* (cat. no. 25);
Zhao Meng, *The Impression of Water* (cat. no. 32)
Second row, left to right: Sin-ying Ho, *Hero no. 2—Crouching Tiger
and Hidden Dragon* (cat. no. 26); Lu Bin, *Fossil 2004 III* (cat. no. 29)
Bottom row, left to right: Wayne Higby, *EarthCloud Sketch / Gold #3*
(cat. no. 41); Ah Xian, *China, China—Bust 35* (cat. no. 44)

Frontispiece
Detail of vase by Zhu Dequn (cat. no. 39)

Photo Credits

ESSAY ILLUSTRATIONS

p. 1, fig. 1; p. 3, fig. 3; p. 4, fig. 5	Fang Lili
p. 2, fig. 2	Courtesy of the Jingdezhen Archives
p. 3, fig. 4	Courtesy of the Jingdezhen Porcelain Company
p. 23, fig. 1	© 2007 Peabody Essex Museum, Salem, Massachusetts, Photo by Dennis Helmar
p. 24, fig. 2	Photo by Paul Macapia
p. 31, fig. 3	Courtesy of the artist

MAPS

Maps 1–3	Peter Lukic

CATALOGUE ILLUSTRATIONS

nos. 1, 3–16, 19, 20	Courtesy of Chen Haibo
nos. 2, 24, 31–36	Maggie Nimkin Photography
no. 21	Alexandra Negoita
nos. 22, 23, 25–27, 29, 30, 44–47	Courtesy of the artist
no. 28	Peter Wing
nos. 37–40	© Atelier Chu Teh-Chun/ Manufacture de Sèvres/ Marlborough Gallery. Courtesy of FEAST Projects, Hong Kong
nos. 41–42	Brians Oglesbee
no. 43	David Revette Photography

CONTENTS

LENDERS TO THE EXHIBITION

Ah Xian
Beatrice Chang
Chen Haibo
James J. Chin
Everson Museum of Art
Wayne Higby
Sin-ying Ho
Mee-Seen Loong
Lu Bin
Manufacture Nationale de Sèvres
Private collection
Private collection, Hong Kong
Zhu Legeng

EXHIBITION SPONSORS

This exhibition, related programming, and catalogue
*have been made possible in part through the generous support of the following **

BENEFACTORS

Gayle Ong and James J. Chin
Shanghai Yipinghui Culture Development Co., Ltd.

CONTRIBUTORS

Anla Cheng and Mark Kingdon/The Kingdon Foundation
Susan and Jay Goffman
Virginia A. Kamsky
Lianjun Ma
Oscar L. Tang
Wan-go H.C. Weng

SUPPORTERS

Carolyn Hsu-Balcer and René Balcer
Hart and Nancy B. Fessenden
The J. and H. Weldon Foundation, Inc.

INDIVIDUALS

Lawrence Benjamin
Lois M. Collier
Jay Collins
Richard A. and Ruth Dickes
Charlotte Ford
Henry P. Johnson
Susan and Chip Kessler
Sanjeev Khemlani
Kevin J. and Laura Lavin

T.K. Lee
Anthony Lo
Margro R. Long
Robert W. and Virginia Riggs Lyons
Gerard M. Meistrell
William N. Raiford
Sophia and Abel Sheng
George Sing and Nellie Chi
Dana Tang and Andrew Darrell

* At the time of printing

MESSAGE FROM THE BOARD CHAIR AND PRESIDENT

China Institute is proud to present *New "China": Porcelain Art from Jingdezhen, 1910–2012.* Once known in Europe as "white gold," few objects have been as universally and historically adored as Chinese porcelain, and its most famous production center, Jingdezhen, has produced many of our world's most expertly crafted and aesthetically refined works of art throughout its one-thousand-year history.

With the arrival of New China and the advent of modernism, the art of Chinese porcelain underwent a humanistic transformation. During the early 1900s, modern practitioners of the art form catalyzed the rise of the "studio artist," a conception that is Western in origin. Porcelain no longer had to be produced within the anonymity of a collective system. The medium developed into a true art form that can be vastly individualistic, powerful, and introspective.

This exhibition pays tribute to twenty-five artists, whose pioneering works have changed our perception of Chinese porcelain forever. They revitalized and re-imagined the art form within Jingdezhen's highly challenging, resourceful, and creative atmosphere of the twentieth and twenty-first centuries. They meditated upon the difficult question of traditional versus modern and articulated the definition of "Chinese" in a global context. Through their creations, Jingdezhen's venerable one-thousand-year tradition remains alive and extremely potent. The future of Chinese porcelain has yet to be seen in its full extent and one could only imagine the grand possibilities that are to come.

We are extremely grateful to our generous lenders and supporters—many of whom are the artists themselves—who are willing to share their important artworks with China Institute and the public. We would like to extend our thanks to Willow Weilan Hai Chang, Director of China Institute Gallery, whose vision for *New "China"* is a testament to China Institute's devotion to organizing exhibitions that illuminate important trends in contemporary Chinese art. We would like to thank the guest curators and authors of this catalogue, Fang Lili, a leading author on Jingdezhen studies and the Director of the Art Anthropology Research Center of the Chinese National Academy of Arts, and Nancy Selvage, former Director of the Ceramic Program at Harvard University. The success of this project is also a direct result of the continuing support of the Board of Trustees of China Institute, the Friends of the Gallery, the members of our Gallery Committee and our sponsors of the exhibition. Without them, this project would not have come to fruition.

Virginia A. Kamsky
Chair, Board of Trustees

Sara Judge McCalpin
President

FOREWORD

China—mention this word in English, and the image of fine porcelain ware would just as likely come to mind as the country. Porcelain is a Chinese invention with a long history of development traced by Chinese scholars back to the third century in the late Han dynasty. By the Tang dynasty, different kiln areas of China had already become famous for their porcelaneous or porcelain products; there were green Yue ware, or celadon, from Zhejiang in the south and white Xing ware from Hebei in the north. Porcelain achieved its most subtle beauty with the "five classic wares" of the Song dynasty: Ru, *guan*, *ge*, Jun, and Ding. However, it is *qingbai* ware of the Song and Yuan dynasties that marks the beginning of Jingdezhen's fame as the Porcelain Capital of China. Jingdezhen would flourish from the success of its exports, and its porcelain would blossom with various innovations in colored glazes, painting techniques, and sculptural effects under imperial patronage in the Ming and Qing dynasties.

For over a thousand years, porcelain has been treasured by the Chinese. It was widely used for purposes that ranged from mundane utensils for drinking and eating to ritual vessels for imperial offerings. Various types of Chinese porcelaneous or porcelain wares had been exported since the third century to neighboring countries in Asia and since the sixteenth century to the West. The desire for porcelain swept the world, and it became a leading status symbol of a fashionable life. Attempts to re-create or imitate Chinese porcelain were made in many countries until finally, in 1709, a hard paste porcelain was made in Germany; soon after, a porcelain factory was established at Meissen.

In the early twentieth century, ceramic production at Jingdezhen declined in the face of political turbulence and a depressed economic environment. Moreover, competition from foreign ceramic producers such as Japan, Britain, and Germany crashed the market for Chinese ceramics. Consequently, both government agencies and private individuals combined their efforts to establish companies to save this national industry; beginning in Hunan and Jiangxi, eventually over thirty companies were formed across the nation. While focusing on production, some companies, such as the Jiangxi Porcelain Company, also encouraged artistic creativity.

Like a stream in the big ocean of porcelain production, ceramics became an artistic endeavor in Jingdezhen at the beginning of the twentieth century. This new idea first bloomed in the painted porcelain panels of the Eight Friends of Mount Zhu, a group of artists who adapted the highly respected Chinese literati four excellences (poetry, calligraphy, painting, and seal engraving) to porcelain decoration. Together with their students, this first celebrated group of ceramic artists in China led the new artistic direction of Jingdezhen. Although the technique might seem like mere borrowings from another medium, it did give Jingdezhen porcelain a new look.

Painting remains an option among today's artists who choose porcelain as a medium, but it has become more expressive, without the limitation of literati subject matter. The artist today can make use of three-dimensional sculptural approaches or combine the art of painting onto a three-dimensional form for a multi-faceted artistic effect. In summary, porcelain has become a medium in which artists could more freely express themselves and articulate their personal concepts. Porcelain art is likely to be a continuing trend in Chinese contemporary art.

For many years, I had intended to organize an exhibition exploring how this ancient Porcelain Capital is doing in the contemporary ceramic world, especially for those who might erroneously think that its only activity is the copying of masterworks. But I didn't think I could find a suitable scholar for such a project or enough artworks to form an exhibition.

One spring day in 2009, the Chinese cultural consul Zhai Deyu sent an e-mail asking me to receive a special couple from China; one was an artist and the other a scholar. Almost at the same time, a similar request came from New York City's Queens College. Thus, I came to meet with Zhu Legeng, the artist, and Fang Lili, the scholar. I had been intrigued for some years by Fang's book, *Jingdezhen minyao* (The Common Kilns of Jingdezhen), which investigated many facets of private workshop practice, including worship of the God of the Kiln. I had very much wanted to someday meet the author. Now, there she was in front of me: petite, dressed in a loose outfit, and wearing a constant sweet smile on a round face hugged by short black hair. However, it was only after her American friends highly recommended the China Institute Gallery for its quality and its influence that we started a serious discussion which would lead to this project. In the summer of 2010, Lili, Nancy Selvage, and I had a long meeting at the Tibet Building Hotel in Beijing to discuss the selection of artists as well as the subject of the exhibition. Then, the three of us traveled together to Jingdezhen in the fall of 2011 to visit artists' studios and collectors. We added the works of earlier, twentieth-century Jingdezhen artists and others to our list, and eventually the theme of Jingdezhen's hundred years of porcelain art became clear.

This exhibition begins in the early years of the Republic of China, when Jingdezhen was still the first choice for commissioned "imperial" porcelains. In this period, vases marked "Juren Tang" are believed to have been produced for Yuan Shikai (1859–1916), the President of the Republic of China. Works produced by the pioneering Jiangxi Ceramic Company evidenced its effort to revive the nation's traditional ceramic production while employing the artistic approach of the Eight Friends of Mount Zhu, a group led by Wang Qi. Later artists and ceramic art educators, like Wang Xiliang and Zhou Guozhen, illustrate the endeavor of Jingdezhen ceramists to work with modern artistic ideas. The exhibition continues with today's young or new artists who effectively use Jingdezhen as their creative base; whether working from tradition, adapting traditional art, or criticizing and breaking traditions, all use the porcelain medium and its techniques to freely express themselves. The selected artists come from various parts of the world, but all are somehow attracted or connected to Jingdezhen. Thus, this exhibition manages, within its limited space, to reflect a hundred years of ceramic development in Jingdezhen, to celebrate its place in today's global context, and to reveal the ample possibilities for its future.

I would like take this opportunity, at a moment when the catalogue is almost ready to print and the installation just waiting for the arrival of the artwork, to thank all the people who generously sponsored this exhibition as well as the Board of Trustees, Gallery Committee, and China Institute's president, Sara McCalpin, all of whom supported the project. My thanks also go to all the lenders and artists in the exhibition; to the two guest curators Dr. Lili Fang and Nancy Selvage, for their scholarly work; and to the gallery staff—Jennifer Lima, Yue Ma, and Eva Wen—who worked diligently in every aspect of the project. I am greatly indebted to the team of specialists who worked with us: J. May Lee Barrett, for her valuable suggestions and careful, knowledgeable editing; Perry Hu, for his perfect exhibition design; and Peter Lukic, for his beautiful catalogue design. For her public relations effort, I am further indebted to Nicole Strauss. I am also grateful to the gallery's docents and volunteers for their continued contributions of time and energy. And I cannot thank enough the loyal Friends of the Gallery for their various expressions of support. Finally, my thanks go to all the many people, although unnamed, who also helped with or cared about this exhibition. I hope all our visitors and readers come to appreciate the allure of porcelain, an art born from fire and clay, in which the profound human connection with the earth is expressed with love and passion.

Willow Weilan Hai Chang
Director, China Institute Gallery

前言

在英文中，中国与'瓷器'同名，提到中国便让人想到瓷器。瓷器，这一中国的发明，自汉末初成，到唐代已有南青北白之誉，宋代瓷艺的雅致，超寰绝伦，汝官哥钧定五大名窑，各领风骚。然而，宋元以来，景德镇始以青白瓷名扬天下，而终于赢得'瓷都'之美称，其于各式釉色，绘彩，瓷塑等各方面的发明和技艺，得到明清两代皇室的赏识御用，瓷器的制作，泱泱大貌，为一国之首。

瓷器千年来为国人所喜用，从常人之饮食器具到皇家之御用礼器，无所不能。自3世纪以来近 销邻邦，自16世纪远销西方，引领时尚，风靡世界，西方纷纷进口和仿效，直到1709年德国麦森首先创烧成功硬质瓷器并建立工厂。

民国初年以来，国内政局的动荡和经济的不景气，加上西洋瓷器如日本瓷，英国瓷和德国瓷的冲击市场，中国的瓷业经历着衰退，瓷都景德镇也遭殃及，瓷窑数量锐减。自民国初年的二十世纪之始，中国官商结合，湖南江西首开先河，全国先后成立不下三十多个瓷业公司，除了抗衡外国瓷器的倾销中国市场，振兴民族产业外，有些也十分重视艺术创作，例如江西瓷业公司对瓷艺的倡导。

虽然这只是瓷器大宗制造中的涓涓细流，但却因此开启了瓷器制作中的新想法，使现代瓷艺，不同于日用器的传统，而逐步成为一种艺术创作的材质，成为代现代艺术家所言的一种载体。虽然江西瓷业公司本身在艺术上的创树未著，但其影响，间接地是景德镇一批瓷器艺人更加侧重的艺术创作，首先是绘瓷，在瓷器上的绘画，尤其在瓷板上的成套的绘画，将中国视之艺术最高境界的四绝之诗书画印，引入瓷器之上。而有'珠山八友'的诞生，其弟子门徒的延续，形成景德镇新的艺术方向。虽然借助他山之石，但给了景德镇瓷业一个新的气象。

现代艺术家，喜欢选用瓷这一材质来创作的，一是沿着绘瓷的路子继续，但是所绘的题材和手法是以自己想画的为主，不再套用以往文人画的题材或笔法。一是用立体的表现，在三维空间的雕塑作品中，试图突破传统的一些题材和造型。或将平面的绘画与立体的器形相结合，来表达一种双重的现代语境。总之，现代艺术家，以瓷土为媒材，来阐述他们心目中的感想和理念，实在是现代中国瓷器艺术的一个走向。

多年来，我一直有制作一个现代中国瓷艺展览的想法，特别是常听到别人问起这个古老瓷国的瓷艺现状，不希望中国现代瓷艺只是仿造老祖宗的东西而已，但一直苦于找不到合适的策展人和艺术品。

2009年仲春的一天，纽约总领馆的翟德育文化参赞给我发来一个邮件，请我接待一个瓷艺艺术家和一个研究景德镇的学者。同时，我还接到纽约皇后学院发来的邮件，也请我接待这两位艺术家和学者。于是，我结识了朱乐耕和方李莉。方李莉的名字是我几年前就知道的，我曾为一本《景德镇民窑》的著作所吸引，其中关于景德镇民窑的各方面包括窑神的敬供，作者都有亲身的调查，我曾自掏腰包，买下那本厚厚的书，并且有过哪一天能和作者聊聊的念头。这真是天意，现在她就在我的面前。个子不高，衣着飘飘，浓黑短发簇拥的圆脸上，永远是笑容可掬。她一开始觉得我们的场地太小，并未在意，及至回到美国朋友家，听别人盛赞我馆的展览及其影响，遂继续了我们之间的探讨。2010年夏，李莉，Nancy和我三人在北京的西藏大厦开了长长的会，讨论选择瓷艺艺术家和展览的主题，2011年秋，我们三人又亲赴景德镇，访问艺术家，拜会收藏家。这个过程其实是在不断推进的，随着选择艺术家的过程，逐渐地明了了以景德镇为核心的选择方向，并增添了二十世纪初景德镇陶瓷艺人的作品，如此，一个以景德镇百年瓷艺创作的主题终于形成。

这一展览，从民国初年，景德镇承袭传统，仍然为制作御瓷之首选，曾为民国大总统袁世凯制作用瓷，有'居仁堂'号者为佐证，以及民国初年江西瓷业公司的器物之例，见证其为振兴民族产业，倡导瓷器艺术，开拓了在日用瓷向瓷艺方向的发展，到以王琦为首的珠山八友，和同时代的青花大王王步的作品，到王锡良、周国桢等开创景德镇陶瓷现代教育的前辈，展现了景德镇两三代艺人对瓷艺的孜孜追求，到现代中青年承古启今，融合中外，以景德镇为创作基地，或从景德镇汲取灵感，或借鉴传统，或批判传统，或挣脱传统，但都更自由地以瓷土为材质进行创作，从题材到观念，

从技法的绘彩，雕塑，捏塑，装置，录像等，多种多样，展览中精心挑选的每一个艺术家，代表来自多个国家和地区，但都展示与景德镇息息相关的某一点，因此，这一展览虽然精炼，但试图以高度浓缩之各个切入点，展示中国自二十世纪以来景德镇瓷艺创作的百年进程，在当今国际舞台上的表现，和将来发展的无限可能性。

在此展览图录即将付梓，展览陈列只欠东风之际，我愿借此机会感谢所有赞助这一展览的各位志士仁人，感谢董事会、艺术委员会和社长江芷若的支持，感谢两位客座策展人方李莉和 Nancy Selvage 的努力工作，以及所有借展艺术家和借展单位的参与，感谢我美术馆各位职工李轶青、马玥和温玺的齐心协力，并衷心感谢我的专家梯队：钟美梨的细致而专业的英文编辑，胡维智尽善尽美的展览设计，皮特。陆克奇兼顾各方的图录设计，以及尼可尔。斯妆丝的公关宣传，我愿感谢我馆的讲解员和义工们一贯的奉献。感谢我馆忠诚的美术馆之友和所有帮助和关心这个展览的人。但愿所有的人都能从展览中感受到这从土与火的冶炼中升华的瓷艺的魅力，和所寄托的我们人类对土地的厚爱与痴情。

海蔚蓝　馆长
华美协进社中国美术馆

PREFACE

The curators of this exhibition met in 1998 at an international ceramics seminar in Beijing. This early exchange between a large group of Chinese and Western ceramics artists sparked the beginning of their extended collegial relationship and friendship. Through our shared interests and visions we have reconnected many times in China and the United States throughout the past decade. In 2010, Willow Weilan Hai Chang, Director of the China Institute Gallery invited us to co-curate an exhibition on contemporary Chinese ceramics. Since then we have been working with Willow to develop *New "China": Porcelain Art from Jingdezhen, 1910–2012*. Today, we are very happy and honored to share this exhibition with you.

Our mutual interest in ceramics was enhanced by special geographic circumstances: one of us was raised in Jingdezhen, and the other's career is centered in the Boston area. Jingdezhen's pre-nineteenth century porcelain heritage is well known, treasured, and represented in all of the world's major museum collections, especially in Salem, Massachusetts, at the Peabody Essex Museum, which has an extensive holding of Asian export art, and the Boston Museum of Fine Arts, which has one of the great pioneering collections of Chinese and Japanese art in the US. These collections remind us of the importance of porcelain in early American commerce as well as the great global impact of Jingdezhen's output much earlier in history. So what is Jingdezhen like now? How has this historic "Porcelain Capital" developed and changed? What type of ceramic art is being created there today? Many are eager to know.

Jingdezhen is a very interesting part of China's modernization during the past hundred years of China's five-thousand-year history. It has evolved from a closed traditional ceramics handicraft manufacturing town to an open international metropolis. Inspired by Jingdezhen's traditional culture and highly skilled craftsmen, artists from different districts in China and from countries throughout the world are bringing new vitality to this historic porcelain mecca. That's why this exhibition is called *New "China"*; it refers to new porcelain as well as a new nation.

We express our deep appreciation of Gallery Director Willow Chang for her valuable support, encouragement, and direction during the development of this exhibition. Our gratitude is extended to all the contributing artists for the creative excellence that makes this exhibition so special. Finally we wish to thank the consulting editor, catalogue and installation designers, and China Institute's gallery staff for all the care and expertise provided during the exhibition planning and installation.

<div align="right">

Fang Lili, Director of the Art Anthropology
Research Center of the Chinese
National Academy of Arts
Nancy Selvage, former Director of the
Ceramics Program at Harvard University

</div>

序言

1998年我们两人在北京的一次国际陶瓷研讨会上相识，中西方艺术家的交流激励了我们俩的友谊。几十年来，共同的兴趣和爱好使我们一再地在北京或美国相聚。2010年华美协进社中国美术馆的馆长海蔚蓝邀请我们担任"新瓷：景德镇百年瓷艺，1910～2012"展览的策展人，从那时开始我们与她一起为这次展览而努力工作，今天这个展览终于开幕了，我们由衷地感到高兴和荣幸。

我们一个来自景德镇，一个来自波士顿，这不同的地理环境反而增添了我们对陶瓷的更浓厚的兴趣。19世纪以前，景德镇在陶瓷上的成就是举世皆知的，其瓷器为世界上许多博物馆所珍藏，特别是在麻省赛乐姆的皮宝蒂、艾克赛斯博物馆和波士顿艺术博物馆，其中国景德镇瓷器的藏品和日本艺术品的收藏，是全美国领先的。这些藏品使我们看到瓷器在美国早期贸易中的重要性，以及景德镇瓷器很早便对全球所产生的影响。但是今天的景德镇又怎样了？这个古代的"瓷都"发展成什么样子了？今天景德镇的陶瓷艺术又是怎样的？许多人都一定想知道这些答案。

景德镇是具有五千年文明历史的中国在近百年变迁中的一个有趣的缩影。她从一个传统的手工作坊的内地小镇，变成了一个开放的国际都市。景德镇独一无二的传统、资源、工艺和熟练工匠，吸引着来自世界各地的艺术家，从而给景德镇增添了无限的活力。这一展览名为"新瓷"，既表示了所创造的新瓷，也反映了中国通过百年来现代化的变迁而成为一个新的国度。

我们诚挚地感谢华美协进社中国美术馆馆长海蔚蓝，此一展览，得到她不断地支持鼓励和指点。我们也诚挚地感谢所有参展的艺术家，他们富有才情的创作，造就了这个特别的展览。最后我们感谢展览图录的编辑、设计师和展览设计师，以及美术馆的所有馆员，他们发挥了各自的专长，保证了这一展览的成功。

方李莉
中国艺术研究院艺术人类学研究中心主任
Nancy Selvage
原哈佛大学陶艺工作室主任

CHRONOLOGY
Major Events at Jingdezhen

EARLY HISTORY

HAN DYNASTY (202 BCE–220 CE): Ceramic production begins. The *Fuliangxian zhi* (Gazetteer of Fuliang county [comp. 1783]) records: "Xinping began to make ceramics in the Han dynasty." Xinping is the earliest name of Jingdezhen.

SIX DYNASTIES PERIOD (220–589): Xinping is ordered to pay tribute in the first year of the Zhide period (583–86), Chen dynasty. The *Fuliangxian zhi* records: "A large number of palaces were built in Jiankang in the first year of the Chen dynasty's Zhide period. The court commanded Xinping pay ceramic building materials as tribute. The materials were finely carved but unsubstantial, and they were still unable to be used after remanufacture. Therefore, [they] ceased to serve as tribute."

TANG DYNASTY (618–907): It is believed that this period had wares from the Tao kiln (*Taoyao*) and Huo kiln (*Huoyao*) as well as a "jade-like ware" (*jiayuqi*). These terms were first recorded in the *Fuliangxian zhi* and the *Jingdezhen taolu* (A record of Jingdezhen porcelain [first printed in 1815]), but, to date, evidence for them have not been found at any archaeological site dated to before the Five Dynasties period.

FIVE DYNASTIES PERIOD (907–960): Area starts to produce green and white porcelaneous stoneware. More than ten kiln sites have been discovered, mainly scattered on the banks of South River and in the urban area of Jingdezhen.

SONG DYNASTY, JINGDE ERA (1004–1007): Emperor Zhenzong (Zhao Heng) commands Jingdezhen to produce imperial wares marked with *Jingde nian zhi* (produced in the Jingde year)." Because *qingbai* (bluish-white) ware is so beautiful and widely imitated, it came to be called "porcelain from Jingde town." Since then, the town has become world renowned as Jingdezhen, while the old name, Changnan, has been forgotten.

YUAN DYNASTY, 15TH YEAR OF THE ZHIYUAN ERA (1278): The Fuliang Porcelain Bureau is established at Jingdezhen. It is the only ceramic institution serving the imperial court. Under the administration of the bureau and through the common efforts of local folk kilns, Jingdezhen successfully creates *shufu* glaze porcelain (a kind of light green ware), cobalt-decorated white porcelain, underglaze red porcelain, blue-glazed porcelain, white-decorated blue porcelain, turquoise-glazed porcelain, and so on.

MING DYNASTY (1368–1644)

2ND YEAR OF THE HONGWU ERA (1369): The government sets rules that ritual wares should all be porcelain. An official kiln (*guanyao*) is established in Jingdezhen, Raozhou prefecture, and named simply "Pottery Factory." It produces ritual porcelains on a small scale and in certain styles for imperial use. In the 7th month of the 4th year of the Jianwen era (1402), Zhu Di ascends the throne. He re-establishes the Pottery Factory as the Imperial Ware Workshop (Yuqichang), and it begins large-scale ceramic production. Thus begins The Imperial Ware Workshop in the true meaning of its name.

YONGLE ERA (1403–24): Porcelains are produced in large amounts by the Jingdezhen Imperial Ware Workshop not only for daily imperial use, but also as tribute gifts from the imperial court to foreign countries and as the trade commodities needed in Zheng He's diplomatic mission to the West. In this era, the wares are produced in various shapes and the body and glaze are of good quality.

HONGXI ERA (1425): In the 6th month, Xuanzong is enthroned and the imperial kiln takes on a new look.

Xuande era (1426–1436): Xuanzong changes the era name to Xuande in the next year. The cobalt-decorated white porcelain (blue-and-white ware) produced in this era gains prestige.

ZHENGTONG, JINGTAI, TIANSHUN ERAS (1436–64): This is a low period in Imperial Ware Workshop production. One reason is recurring famines. The *Fuliangxian zhi* records: "Severe famines occurred in 1436/1437, 1452, and 1458." The famines result in the flight and shortage of conscripted workmen. In dealing with this situation, Emperor Yingzong announces: "Go back to work with all sins forgiven. Two years of corvee labor will be eliminated, and better treatment will be given."

JIAJING ERA (1522–66): Transitional measures are taken in the Imperial Ware Workshop. One is a change in management; the other is the system of *guan da min shao* (official/folk production), whereby private kilns are enlisted to fire the imperial wares.

WANLI ERA (1573–1620): With the thriving of a commercial economy and increasing cost of production, the Imperial Ware Workshop begins to sell not only their inventory, but even official porcelains bearing the current Wanli mark. In 1608, the Workshop stops production because of the turbulent political situation.

JIAJING ERA TO CHONGZHEN ERA (1522–1644): Japan and many European countries buy porcelains from Jingdezhen; the international and national market is booming. After breaking away from the control exercised by the official kilns, folk kilns in Jingdezhen develop rapidly and a trend toward capitalism begins to emerge.

QING DYNASTY (1644–1912)

11TH YEAR OF THE SHUNZHI ERA (1654): The Imperial Kiln Workshop (Yuyao chang) is established, closing 6 years later in 1660. (It replaces the Imperial Wares Workshop, and the labor system is switched from corvée to hired.)

10TH YEAR OF THE KANGXI ERA (1672): The Kangxi emperor, Xuanye, commands the production of some ritual porcelain ware for his father, the Shunzhi emperor.

13TH YEAR OF THE KANGXI ERA (1675): The ceramic industry is heavily damaged because of the Revolt of the Three Feudatories led by Wu Sangui and others.

19TH YEAR OF THE KANGXI ERA (1681): The official kilns begin large-scale production.

20TH TO 27TH YEAR OF THE KANGXI ERA (1682–89): Zang Yingxuan, an official in the Ministry of Works, is appointed to supervise the imperial kiln at Jingdezhen. A large number of fine imperial porcelains are made under Zang's management; these wares are called *Zangyao qi* (Zang kiln wares).

44TH TO 51ST YEAR OF THE KANGXI ERA (1706–13): Lang Tingji, governor of Jiangxi, is appointed to Jingdezhen as superintendant of the Imperial Kiln Workshop. The official porcelains produced under his management are called *Langyao qi* (Lang kiln wares).

4TH YEAR OF THE YONGZHENG ERA (1726): Nian Xiyao is appointed by the emperor to be superintendant of the Imperial Kiln Workshop at Jingdezhen. The exquisite porcelains fired under his supervision are referred to as *Nianyao qi* (Nian kiln wares).

6TH YEAR OF THE YONGZHENG ERA TO THE 20TH YEAR OF THE QIANLONG ERA (1728–1756): Tang Ying is appointed to Jingdezhen as superintendant of the Imperial Kiln Workshop and becomes the longest serving officer in that position during the Qing dynasty. The official porcelains produced under his supervision are called *Tangyao qi* (Tang kiln wares).

JIAQING ERA (1796–1820): No superintendant is appointed to the Imperial Kiln Workshop in Jingdezhen beginning in the Jiaqing era. Local officials are put in charge of the work.

5TH YEAR OF THE XIANFENG ERA (1855): The rebel army of the Taiping Heavenly Kingdom enters Jingdezhen and sets fire to the Imperial Kiln Workshop.

5TH YEAR OF THE TONGZHI ERA (1866): Li Hongzhang collects funds and rebuilds the seventy-two rooms used for ceramic production.

22ND YEAR OF THE GUANGXU ERA (1896): Zhang Zhidong, governor-general of Huguang, presents a memorial to the throne: "The merchant-gentry of Jiangxi request a steam launch and a porcelain and sericulture school." It is the first mention of a ceramics school.

2ND YEAR OF THE XUANTONG ERA (1910): Jiangxi Porcelain Company is established. The Imperial Kiln Workshop ceases production.

2ND YEAR OF THE XUANTONG ERA (1910): Kang Da, general manager of the Jiangxi Porcelain Company and first head of the Jingdezhen Chamber of Commerce, proposes to the department of education the joining of Zhili (now, Hebei), Hubei, Jiangsu, and Anhui in a collaboration to fund the establishment of the China Ceramics School (Zhongguo tao xuetang). This school was first set up in Boyang (Poyang) county, formerly known as Raozhou, and for this reason it was also called the Raozhou Ceramics School.

MODERN ERA

1912: Jiangxi Ceramics School is established in Boyang county (originally Poyang) and renamed Jiangxi Provincial Class A Industrial Ceramics School in 1915.

1925: Jiangxi Ceramic Bureau was established in Jingdezhen.

1928–49: There are 1451 workshops in the industry of manufacturing the semi-finished ceramic products; but only 367 are still running by 1948. There are 128 kilns running in 1928, but the number is to decrease to 90 kilns by 1947 and only 8 kilns by 1949.

1934: Jiangxi Ceramic Industry Management Bureau is established in Jingdezhen.

1951: A preparatory committee for cooperatives is established, and three large-scale ceramic production cooperatives are founded.

BY THE END OF 1952: Three processing cooperatives and five production cooperatives are established. Gradually, small-scale private factories form jointly managed factories.

1955: The Ceramic Art Skill School is founded in Jingdezhen.

END OF 1955: Thirty-eight handicraft cooperatives and nineteen private ceramic factories are formed in Jingdezhen.

FEBRUARY 1956: A transition from a private-run to government-private joint cooperation model is accomplished in every industry in Jingdezhen. There are ten joint government-private factories and twenty cooperatives running factories in the ceramic industry.

1958: Jingdezhen Ceramic Institute (formerly the Jiangxi Provincial Class A Industrial Ceramics School) is established and continues to this day as the only institution of higher learning dedicated to the ceramic arts.

1958–61: Over ninety percent of the ceramic industry enterprises expand their facilities and add more equipment. Generally, technology advances from manual to mechanized in many aspects, such as shaping the raw materials, decorating the ceramics, and so on.

1980: China implements economic reform and internationalization. A transition is made from a planned economy to a market economy.

BEGINNING IN 1990: Ceramic workshops reappear in the rural areas around Jingdezhen, producing and displaying archaized porcelains.

BEGINNING IN 2000: The Jingdezhen Ceramic Fair and the Jingdezhen Contemporary International Ceramics Exhibition are held every October, attracting ceramic enterprises and artists from all over the world.

Compiled by Fang Lili

景德镇大事记

早期

汉代（公元前202年～公元220年）：开始烧制陶瓷器，《浮梁县志》记"新平冶陶，始于汉世"。新平镇是景德镇最早的名称。

三国、两晋、南北朝（公元220～589年）：《浮梁县志》记"陈至德元年，大建宫殿于建康，诏新平以陶础贡，雕镂巧而弗坚，再制不堪用，乃止"。

唐代（公元618～907年）："陶窑"、"霍窑"及"假玉器"见于《浮梁县志》、《景德镇陶录》中，但至今未发现五代以前的遗址。

五代（公元907～960年）：生产青瓷和白瓷。已发现窑址十几处，主要分布在景德镇南河两岸和现今的市区范围。

宋景德间（1004～1007年）：赵恒(真宗)命景德镇镇烧造御器，器底书"景德年制"款，由于青白瓷"光致茂美，四方则效，于是天下都称之为景德镇瓷器。此后景德镇之名著，而昌南（这以前景德镇的名字）之名遂微"。

至元十五年（1278年）：设立景德镇浮梁瓷局，这是当时全国唯一的一所为皇室服务的制瓷机构。在瓷局的掌管和当地民窑的共同努力下，元代的景德镇创烧了枢府釉瓷、青花、釉里红、蓝釉、蓝地白花、孔雀蓝釉瓷器等。

明代

洪武二年（1369年）：明王朝确立祭器皆用瓷的制度。饶州府景德镇官窑也于此时设立，初设时名为陶厂，规模很小，按样为朝廷烧制祭祀用瓷。建文四年（1402）七月，朱棣登基，改陶厂为御器厂，开始了较大规模的烧造，真正意义上的御器厂由此开始。

永乐（1403年～1424年）时期：景德镇"御器厂"生产的瓷器不仅大量供应宫廷生活需要，还要满足明廷对外国入贡者的答赠和郑和出使西洋所需的礼品及贸易商品。这一时期胎釉精细，造型多样。

洪熙元年（1425年）：六月宣宗即位，宣德御窑的面貌可谓焕然一新，宣德青花瓷久负盛名。

正统（1436年）、景泰、天顺三朝（1436～1464年）：是御器厂生产的低谷期。其烧造不振的原因之一是屡次的饥荒。据《浮梁县志》记载，景德镇正统元年（1436）到二年（1437）、景泰三年（1452）、天顺二年（1458）皆有大的饥荒。而饥荒也导致了匠役的逃逸和良匠的匮乏，针对这种状况，英宗曾下诏"悉宥其罪，令各复业著役，免其差徭二年，所司善加优恤"。

嘉靖（1522年～1566年）时期：御器厂进行了一系列变革，首先是管厂官制度的调整和变化。其次是出现了"官搭民烧"制度。

万历（1573年～1620年）以后：随着商品经济的发达和生产瓷器成本的加大，景德镇御窑厂不仅开始出卖库存瓷器，就是当朝的官款瓷器也可以作为商品出卖了。万历三十六年（1608）由于时局的动乱，御器厂的生产不堪重负，停止烧造。

嘉靖、万历开始直到天启崇祯（1522年～1644年）：欧洲、日本等许多国家陆续到景德镇购买瓷器，国际国内市场空前繁荣，摆脱了官窑的控制后，景德镇民窑陶瓷业得到大力发展，景德镇制瓷业开始出现资本主义萌芽。

清代

顺治十一年（1654年）：建立御窑厂（清代改御器厂为御窑厂，改匠役制为雇佣制）。至顺治十七年（1660年）由巡抚张朝璘疏请停止。

康熙十年（1672年）：康熙帝玄烨曾为其父顺治帝陵墓定烧了一部分祭器，除此之外，官方文献中并无其它重要烧造的记录。

康熙十三年（1675年）：因吴三桂等煽起三藩之乱，窑事遭到严重破坏。

康熙十九年（1681年）：官窑器开始得到大规模生产。

康熙二十年始直至二十七年（1682年～1689年）：由工部虞衡司郎中臧应选任督陶官。烧制出开国以来最大批最精美的御用瓷，即所谓的"臧窑器"。

康熙四十四年至五十一年间（1706年～1713年）：由在任的江西巡抚郎廷极任御窑厂督陶官。他监制的官窑器即谓之为"郎窑器"。

雍正四年（1726年）：清朝皇帝任命年希尧为御窑厂督陶官，监烧出一批美器，世称"年窑"。

雍正六年至乾隆二十年（1728年～1756年）：任命唐英御窑厂陶务官。他是清代在位最长的督窑官。他监制的官窑器即谓之为"唐窑器"。

嘉庆（1796年～1820年）时期开始：景德镇御窑厂便无专司其事的督陶官，由地方官兼管。

咸丰五年（1855年）：太平天国军进入景德镇，烧毁了御窑厂。

同治五年（1866年）：李鸿章筹资重建堂舍七十二间。

光绪二十二年（1896年）：湖广总督张之洞在上《江西绅商请办小火轮、瓷器及蚕桑学堂》奏折中，第一次提及倡办陶业学堂。

宣统二年（1910年）：景德镇建立江西瓷业公司。御窑厂停烧。

清宣统二年（1910年）：由江西瓷业公司总理、景德镇商务总会首任总理康达，呈请学部批准，联合直隶(河北)、湖北、江苏、安徽等省协同出资创办中国陶业学堂，该学堂最初建在景德镇附近的波阳县，故又称为"饶州陶业学堂"。

现代

1912年：景德镇成立"江西省立陶业学校"，1915年更名"江西省立甲种工业学校"。

1925年：景德镇设立江西陶务局。

1934年：在景德镇设立了江西省陶业管理局。

1928年：全镇制坯行业（包括圆器、琢器）开工的厂家共有1451户，到民国三十七年（1948年）已减至367户。

1928年：全镇开烧的瓷窑（包括柴窑、槎窑）共有128座，到民国三十六年（1947年）减至90座，至1949年建国前夕已减至8座。

1951年：成立合作总社筹备委员会，并组成了3个规模较大的瓷业生产合作社。

到1952年底：成立了3个加工合作社和5个生产合作社。私营小厂也逐步组成联营工厂。

1955年：景德镇创办陶瓷美术技艺学校。

1955年底：全市陶瓷组成38个手工业合作社和19个私营的瓷厂。

1956年2月：全市各行业完全实现了私营工商业的公私合营和手工业的合作化。其中陶瓷业实行公私营的工厂10个，合作社营的工厂20个。

1958年：景德镇陶瓷学院建立（原江西省立甲种工业学校），至今仍是全国唯一的一所致力于陶瓷艺术的高等学府。

1958年至1961年三年：全市90％以上的陶瓷工业企业进行了扩建增添设备，普遍进行了从原料、成型、彩绘等由手工化到机械化方面的技术改造。

1980年：国家实行改革开放，有计划经济发展为市场经济。

1990年：景德镇周边农村开始恢复陶瓷手工艺作坊，生产仿古瓷与陈设瓷。

2000年：自此，每年10月定期召开景德镇陶瓷博览会与景德镇当代国际陶艺展，吸引全世界相关的陶艺家和陶瓷器参展与交流。

（方李莉编撰）

TRADE PORTS AND GLOBAL MARKETS FOR JINGDEZHEN CERAMICS*
贸易口岸与景德镇瓷器的世界市场

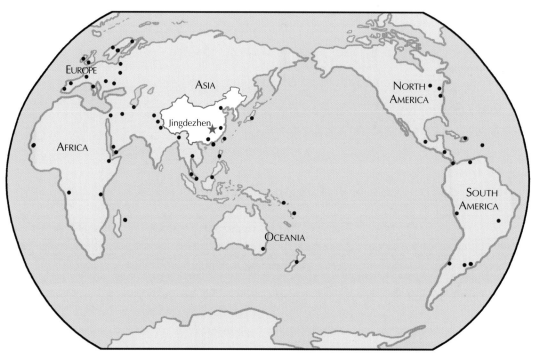

MAJOR TRADE PORTS IN CHINA
中國的主要货港

Guangzhou	广州
Hong Kong	香港
Macau	澳门
Quanzhou	泉州
Taipei	臺北

EUROPE 欧洲

Amsterdam	阿姆斯特丹
Berlin	柏林
Dublin	都柏林
Helsinki	赫尔辛基
Lisbon	里斯本
London	伦敦
Madrid	马德里
Oslo	奥斯陆
Paris	巴黎
Prague	布拉格
Rome	罗马
Stockholm	斯德哥尔摩
Warsaw	华沙

MIDDLE EAST AND ARABIAN PENINSULA
中东和阿拉伯半岛

Aden	亚丁
Amman	安曼
Baghdad	巴格达

Istanbul	伊斯坦堡
Sana'a	萨那
Tehran	德黑兰

AFRICA 非洲

Dakar	达喀尔
Dar es Salaam	达利斯萨拉姆
Djibouti	吉布提
Kinshasa	金沙萨
Port Louis	路易港

CENTRAL ASIA 中亚

Islamabad	伊斯兰堡
Kabul	喀布尔

SOUTH AND SOUTHEAST ASIA
南亚和东南亚

Bangkok	曼谷
Brunei	文莱
Dhaka	达卡
Kuala Lumpur	吉隆坡
Manila	馬尼拉
New Delhi	新德里
Singapore	新加坡

EAST ASIA 东亚

Tokyo	东京

OCEANIA 澳大利亚

Canberra	堪培拉
Port Vila	维拉港
Suva	苏瓦
Wellington	惠灵顿

NORTH AMERICA 宋体北美洲

Boston	波士顿
Mexico City	墨西哥城
Ottawa	惠灵顿
Philadelphia	費拉德爾菲亞
Salem, Massachusetts	麻塞諸塞州賽勒姆

**CARIBBEAN AND CENTRAL AND
SOUTH AMERICA** 加勒比海和中南美洲

Brasília	巴西利亚
Buenos Aires	布宜诺斯艾利斯
Caracas	加拉加斯
Lima	利马
Montevideo	蒙德维的亚
Panama	巴拿马
Santiago	圣地亚哥
Santo Domingo	圣多明各
St. John	圣约翰
Tegucigalpa	特古西加尔

*Some regions are indicated by their modern capitals

JINGDEZHEN AND OTHER IMPORTANT KILN SITES

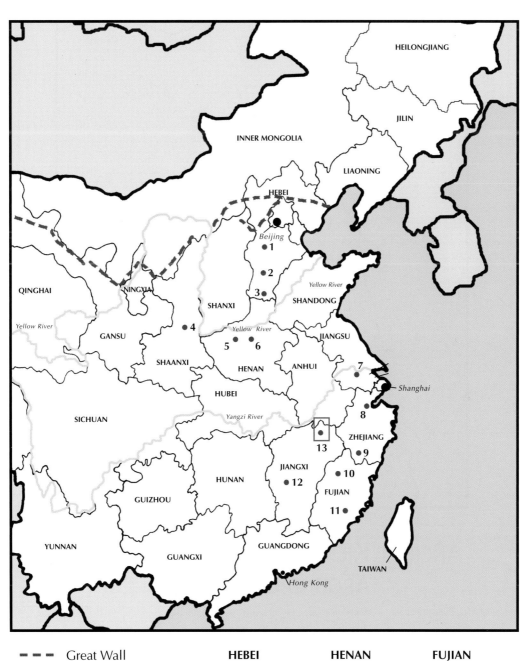

- - - Great Wall

☐ See map on page xxiv

• Kiln site

HEBEI
1. Ding
2. Xing
3. Cizhou

SHAANXI
4. Yaozhou

HENAN
5. Linru
6. Yuxian

JIANGSU
7. Yixing

ZHEJIANG
8. Hangzhou
9. Longquan

FUJIAN
10. Jian
11. Dehua

JIANGXI
12. Jizhou
13. Jingdezhen

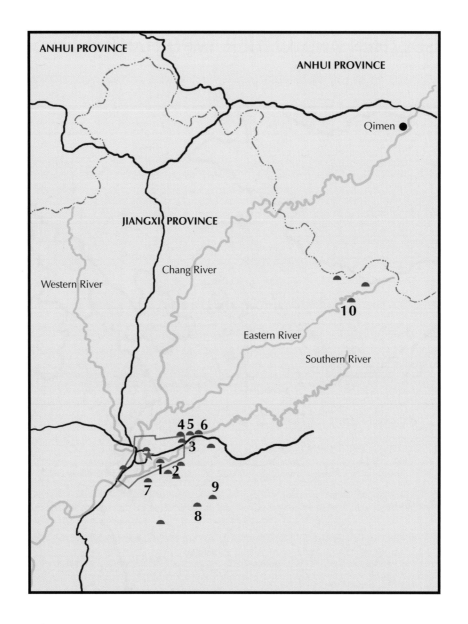

ANCIENT KILN SITES AND RIVER SYSTEM AROUND JINGDEZHEN

★景德镇市	Jingdezhen	6. 湘湖街	Xianghujie	◖	Kiln site
1. 湖田	Hutian	7. 银坑坞	Yinkengwu	▬	Main Roads
2. 杨梅亭	Yangmeiting	8. 南市街	Nanshijie	—··—··—	Provincial Border
3. 塘下	Tangxia	9. 柳家湾	Liujiawan		
4. 黄泥头	Huangnitou	10. 瑶里	Yaoli		
5. 白虎湾	Baihuwan				

JINGDEZHEN AND THE ARTIST: 1910-2012
Fang Lili

The current Chinese term *beipiao* (literally, "drift around Beijing") refers to youths who go to Beijing to pursue their dreams. They keep on "drifting" even when jobless. Beijing, the capital city of China, is not only the center of national culture, politics, and economy, but also the place where the dreams and aspirations of young people have a chance for fulfillment. Recently, a new term, *jingpiao* ("drift around Jingdezhen"), represents a phenomenon in which young artists and recent graduates from fine arts programs around the country come to Jingdezhen to set up art and design studios in pursuit of their dreams. No matter where young people may be, they exude hope and vitality. Jingdezhen, an old town with a thousand-year history of ceramic production, is striding toward the future with youth and vigor. The goal of this exhibition and essay is to demonstrate and discuss the new hope and vitality of Jingdezhen.

GEOGRAPHIC LOCATION AND NATURAL RESOURCES

Jingdezhen is located in northeastern Jiangxi province, bordered on the east by Xiuning in Anhui province and Wuyuan in Jiangxi; on the south by Wannian and Yiyang in Jiangxi; on the west by Poyang in Jiangxi; and on the north and northeast by Qimen in Anhui. It is about 250 kilometers from the provincial capital Nanchang and about 300 kilometers from the coast.[1] Nestled among mountains, the city sits between the Chang and Southern rivers: the Chang River runs across the city, connecting Qimen and Poyang Lake, while the Southern River lies to the southeast. The city was first established on a thirteen-mile stretch along the banks of the Chang River (fig. 1).

The area is rich with natural resources for producing ceramics. There are large tracts of timber around the region, especially pine, Chinese fir, and a kind of fern (*langjicao*), which provided the primary fuel for porcelain production. Raw materials like clay and china stone are found in nearby districts, such as Machang, Gaoling, Dongxiang, Yugan, Leping, Xingzi, and Qimen. A river network is formed by the Chang River and more than fifty of its branches, distributing broadly sufficient quantities

Fig. 1. Hills and forests in the Jingdezhen environs

of the water essential to production, marketing, and transportation in the ceramic industry (see map, p. xxiv). Water is used in clay refining, as well as in powering waterwheels and trip-hammers that pulverize china stone. In addition, the Chang River serves as a transportation route for bringing in raw materials, fuel, and agricultural and farm sideline products as well as for sending out finished ceramic products.

The prosperity and wealth that the ceramic industry brought to Jingdezhen lasted for hundreds of years in the Ming and Qing periods.

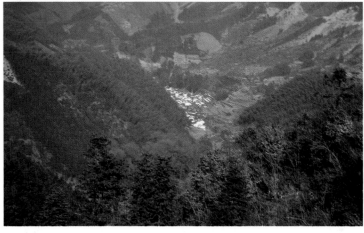

Wang Shimao (1536–1588), an imperial magistrate during the Ming dynasty, recorded a flourishing picture of Jingdezhen:[2]

> All the kilns in China moved to Jingdezhen. Prosperity and wealth of this important center kept Jingdezhen the most prosperous area in Jiangxi province. . . . I was kept awake all night with the thundering of tens of thousands of pestles pounding the ground and the glare from the kiln fires lighting the sky in this so-called Town of Year-Round Thunder and Lighting.

For hundreds of years, Jingdezhen was like one huge handicraft workshop, a deafening and dazzling ceramic production site. The scene was also noted in 1728 by Tang Ying, a scholar-official who was appointed to supervise ceramic production at Jingdezhen. He commented that "with its dense population, it's almost like a metropolis, bustling and crowded with merchants, intersecting streets, and markets containing abundant varieties of goods."[3]

Jingdezhen's historic kilns were built along the Chang River, and the streets, studios, and markets were constructed in relation to the kilns (fig. 2). As a result, Jingdezhen developed according to the north-south orientation of the Chang River. The urban area began with the Guanyin Pavilion in the north and continued through Front Street, Back Street, Little Harbor Mouth, and then straight ahead to South Estuary. The width of the town along the river was as narrow as five hundred meters and as great as two kilometers. This irregular, strip-like urban area was formed in tandem with the development of the ceramic industry, reflecting the distinguishing characteristics of an industrial and commercial city that relied on water transportation (fig. 3).

CERAMIC HISTORY OF JINGDEZHEN

Historical documents state that "Xinping has produced ceramics since the Han dynasty."[4] Xinping is the earliest name of the Jingdezhen district. Although there are no records regarding a ceramic industry in Jingdezhen during the Tang dynasty or the Five Dynasties period, archaeological remains provide clues that Jingdezhen folk kilns existed during those early periods. Dozens of kiln sites from the Tang dynasty and the Five Dynasties period have been discovered in Jingdezhen in the past few years (fig. 4). The sites are scattered mainly along the banks of the Southern River and in today's urbanized area.

Economic growth during the Song dynasty promoted the production of ceramics, and many now-famous kilns emerged across southern and northern China. The Jingdezhen kilns began to grow in fame around the Five Dynasties period, and every hamlet began to fire kilns and virtually every family became involved in ceramics production. During the Song dynasty, Jingdezhen produced

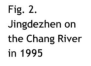

Fig. 2.
Jingdezhen on
the Chang River
in 1995

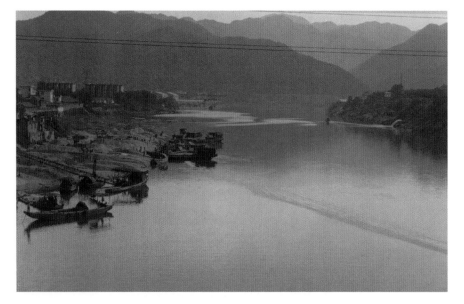

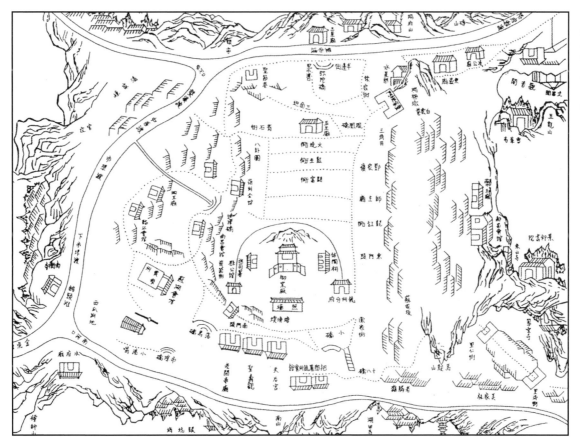

Fig. 3. Map of Jingdezhen in the Jiaqing period of the Qing dynasty. Adapted from Fang Lili, *Jingdezhen minyao* (Beijing: Renmin chubanshe, 2003), p. 20

primarily *qingbai* (bluish-white) ware, which had a glittering and translucent quality similar to jade. The emperor at the time favored *qingbai* ware and commanded Jingdezhen to send porcelains as tribute to the imperial palace. From that time, Jingdezhen was designated as a production center for imperial wares. According to records in the *Annals of Jiangxi* (*Jiangxi tongzhi*), Jingdezhen was "designated as a town in the mid Jingde period [1004–1007] of the Song dynasty with a commission to produce porcelains bearing the inscription 'Jingde' on wares for the government. . . . [The town soon became] "renowned throughout the world as Jingdezhen, while the old name, Changnan, has been forgotten."[5] The town has borne the name Jingdezhen for nearly a thousand years since.

Rulers of the Yuan dynasty favored Jingdezhen porcelain as well. As a result, an officer was appointed to Jingdezhen by the court to supervise ceramic production and commerce. Meanwhile, true cobalt-decorated white porcelain (blue-and-white) was successfully produced on a large scale for the first time, effectively transforming the Chinese ceramics industry.

Jingdezhen's Imperial Ware Workshop (Yuqichang) was established in the early Ming dynasty and lasted for five hundred years until

Fig. 4. Remains of a Five Dynasties kiln site at Jingdezhen

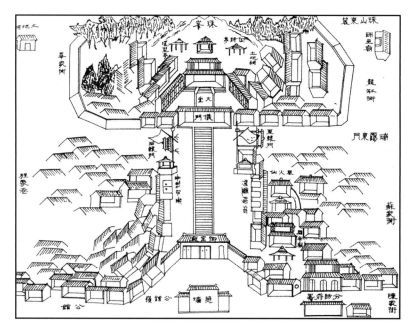

Fig. 5. Drawing of the Imperial Kiln Workshop (originally named the Imperial Ware Workshop) at Jingdezhen. Adapted from Fang Lili, *Jingdezhen minyao* (Beijing: Renmin chubanshe, 2003), p. 105

the late Qing dynasty (fig. 5). This workshop was the manufacturing unit of porcelains reserved exclusively for the emperor. Even though Jingdezhen had been producing porcelains for the emperor since the Song dynasty, the workshops that made them were not strictly speaking "imperial." Those kilns produced imperial wares only at the emperor's command; they manufactured porcelains for local markets as well. Many factors had contributed to the fame of Jingdezhen, including the high quality clay and the benefits that accrued from the creation of cobalt-decorated porcelain for foreign markets beginning in the Yuan dynasty. The Imperial Ware Workshop, moreover, was to set a high standard for workmanship among the artisans. Supplying both domestic markets and those on other continents, Jingdezhen came to be the ceramics capital of the whole world as well as that of China. From the 1400s to the first half of the 1800s, porcelains from this center were exported in great quantities to various countries around the world, especially Europe. As a result, Jingdezhen's exquisite porcelains have had a profound impact on the development of world culture and art.

CHINA'S TRANSITION AND PURSUITS DURING THE LAST ONE HUNDRED YEARS

China encountered tremendous changes during its transition from an agricultural civilization to an industrializing nation beginning at the end of the nineteenth century. As an ancient handicraft town, Jingdezhen also faced huge developmental challenges. In over a hundred years, China has been transformed from a tradition-bound society to a modernized country. In this essay, I have divided this transition into three periods:

1. Early phase of modernization—period of the Republic of China (1911–1949);
2. Mid-phase of modernization—from the founding of the Peoples' Republic of China to the late economic reform and internationalization period (1949–2000);
3. Later phase of modernization—from the late economic reform and internationalization period to the present (2000–).

During these three periods, understanding of the relationship between tradition and modernization differed from time to time and person to person. These differences led to various patterns of development in Jingdezhen and, indeed, to the artistic style of each period.

This exhibition, *New "China": Porcelain Art from Jingdezhen, 1910–2012*, presented by China Institute Gallery, explores the cultural changes in ceramic art during the past century by displaying works created in Jingdezhen during several different periods. The exhibition encompasses (1) works by Jingdezhen literati and artists during the Chinese Republican period; (2) works by professors of the

Jingdezhen Ceramic Institute who established modern ceramics education after 1949; (3) works created in Jingdezhen by artists from around China after the period of reform and internationalization began in the 1980s; and (4) works created in Jingdezhen by Chinese and non-Chinese artists since the year 2000.

Due to the gallery's space limitations, only a small number of works were chosen to represent each period. Although the theme of the exhibition is history, its emphasis is on the "new." Therefore, the majority of the works on display are from the most recent period. The following discussion of the themes presented in the exhibition provides an overview of the historic transition that took place in Jingdezhen.

TRADITION VS. MODERNIZATION

During the Republican period (the first half of the twentieth century), Jingdezhen faced an unprecedented challenge—to make the transition from a traditional to a modern society, that is, to change from handicraft production to mechanized manufacturing processes. The change meant that the workmanship and experience of Jingdezhen craftsmen that had been handed down for a thousand years might be discarded overnight. Jingdezhen's response to the threat was resistance to modernization, based on the fear that modern technology would replace their traditional skills and knowledge. At the same time, they realized that to resist innovation would ultimately be futile, since changes in technology and artistic preference were already beginning to take hold in China. In an attempt to raise the status of handmade work, Jingdezhen craftsmen began to advocate for the appreciation of painting on porcelain as equal in artistic merit to a conventional painting on paper and silk.

Artists of the literati class in China have historically had their own associations, while professional painters had painting schools. But ceramic craftsmen, even those who had made Jingdezhen porcelains renowned around the world, were of a much more humble status, and few of their names survive. Moreover, traditional ceramics craftsmen and workers of the past had no mechanism for gathering or interacting in any meaningful artistic way. However, during this particular period, they found ways to gather as a group. The most representative association formed by ceramic artisans was the Full Moon Society (Yueyuan hui), begun by Wang Qi (1884–1937) and others in 1928. On the fifteenth day of every lunar month, members of the Society took turns hosting meetings in which everyone brought their new works for mutual appreciation and study; at the gatherings they also enjoyed drinking liquor, reciting poems, and painting. Wang Qi was also a member of the "Eight Friends of Mount Zhu," a group of ceramicists that actually included ten members, just as the Jiangxi Poetry Group had members who were not Jiangxi natives and Jingdezhen "five-color ware" had more than five colors. These names are poetic approximations and not intended to be exact.

The Eight Friends of Mount Zhu consisted of ceramic craftsmen, most of whom were well-educated. Deng Bishan and Bi Botao were scholars of the late Qing dynasty; Tian Hexian gave lessons in the Jiangxi Provincial Ceramics Industry Academy; and Wang Yeting and Liu Yucen graduated from Ceramics Decorating Department of the Jiangxi Provincial Class A Industrial Ceramics School in Poyang county. These men were pioneers of reform among Jingdezhen ceramic painters, and they were the first to sign their names on ceramics, intentionally treating them as works of art.

In order to give a full picture of this period, a porcelain painting by each of the ten artists of the Eight Friends of Mount Zhu was chosen for display in the first section of the exhibition (cat. nos. 3–12). All these works were small in size but delicately painted by employing traditional *fencai*, or *famille-rose* (overglaze enamels with a predominance of pink), techniques popular in Jingdezhen at that time. The *famille-rose* technique was created in the Kangxi era of the Qing dynasty (late 17th century) and climbed

to its peak around the Yongzheng period (mid-18th century). It was often featured on imperial wares and became the mainstream of mature ceramic decoration in Jingdezhen (e.g., cat. nos. 1 & 2). The Eight Friends tried to apply this technique to ceramic painting as a way of recreating the effects and artistic approaches of Chinese painting. This was the major aesthetic orientation of Jingdezhen at that time.

Although *famille-rose* porcelain has been the most popular ceramic type in Jingdezhen since the Qing dynasty, blue-and-white porcelains were still favored by the market. Jingdezhen cobalt-decorated blue-and-white porcelains, which reached its full development around the Zhizheng era of the Yuan dynasty (ca. 1340), have always been the most important variety of ceramic produced in Jingdezhen. Porcelains exported to Europe between the Ming dynasty Wanli era (ca. 1560) and the mid-Qing (ca. 1780) dynasty were mainly cobalt-decorated wares. After hundreds of years of production and research, the techniques of blue-and-white wares had reached a high level of achievement by the Republican period. Therefore, this exhibition also features from this period a pair of flower-and-bird vases (cat. no. 13) and a brush pot (cat. no. 14) splendidly painted in cobalt blue by Wang Bu (1898–1968), who was known at the time as "Blue-and-White Wang" (a pun for the "King of Blue-and-White," *qinghua wang*).

In works dating from the Republican period, it is clear that some literati and artists in Jingdezhen no longer identified themselves as craftsmen, but rather as artists. They not only painted porcelain, but sought to master other skills of literati-painters, such as poetry, calligraphy, and even seal carving. Although, these craftsmen did not succeed in saving the Jingdezhen ceramic industry from stagnancy, their work served to pass down and further develop the skills and techniques of Jingdezhen ceramics. They established a foundation for the revival of Jingdezhen's traditional ceramic techniques, as well as oversaw the transition of Jingdezhen from a center of everyday-porcelain production to one of art-porcelain creation.

THE RISE OF MODERN EDUCATION

In order to confront the challenge of modernization following the Republican period, one of the first steps taken in Jingdezhen by the government of the People's Republic was to establish new enterprise patterns and implement modernized management. This was part of its effort to create an industrialized nation of international standing. However, new patterns require new talents. In the Republican period, the Nationalist Party built the Jiangxi Provincial Class A Industrial Ceramics School in Poyang county, near Jingdezhen. After the founding of New China (1949), the school was renamed the Jingdezhen Ceramic Institute under the Communist Party in 1958. This institute is the sole college in China devoted exclusively to ceramics. It has trained numerous ceramic designers and artists who, with more contemporary perspectives, have made important contributions to the transformation of Jingdezhen's ceramic art from traditional to modern.

The exhibition displays works of three professors from the Jingdezhen Ceramics Institute's Fine Art Department. They are famous both as ceramic artists and as art educators, especially Shi Yuren and Zhou Guozhen, founders of the Jingdezhen Ceramics Institute.

Shi Yuren (1928–1998) was a graduate of the Department of Applied Fine Arts, Beijing Central Academy. In 1955, when the Ceramic Art Skill School was founded in Jingdezhen, he was assigned to teach there by the National Higher Education Ministry. After the Jingdezhen Ceramic Institute was established in 1958, he was employed as a professor of ceramic design. In addition to his personal art production, Professor Shi had a great passion for ceramic folk art and research into overglaze-enamel wares, especially five-color ware and red-and-green ware. (Red-and-green ware was first produced in the Song and Jin dynasties [1115–1234]; five-color ware emerged in the Ming dynasty based on

red-and-green ware. Five-color ware is painted in single strokes, which were powerful and vigorous, of bright and lively colors. First produced in the late Ming dynasty, this ware became popular in the Qing dynasty.) Because of Shi's educational background, his works were completely different from those of the local ceramic artists in Jingdezhen; they have a stronger decorative quality and design language while exhibiting a more modern sensibility. His two red-and-green bowls decorated with scholar's rock and bird are included in this exhibition (cat. nos. 17 & 18); they are not large in size but are very splendid, combining traditional and modern decorative painting in a very interesting way.

Professor Zhou Guozhen (1931–) graduated in 1954 from the Department of Sculpture in the Central Academy of Fine Arts, Beijing. He worked in the Jingdezhen Ceramic Research Center after graduation and then worked for the Department of Fine Arts at the Jingdezhen Ceramic Institute as a sculpture teacher. In contrast to the ceramic sculpture tradition in Jingdezhen, and because of his education in modern fine arts, Professor Zhou integrated his sketching skills into his sculptural works with an emphasis on the language of fire and clay. His works (cat. nos. 19 & 20) have introduced new features into traditional Jingdezhen ceramic art.

Professor Yao Yongkang (1942–) graduated in 1966 from the Fine Arts Department of the Jingdezhen Ceramic Institute. He worked in the Institute's Sculpture Department and represents a generation of educators later than that of Professors Shi and Zhou. His innovations included the modern skills of rolling clay slabs and the use of molds, which enabled his works to depart markedly from tradition and opened up a new avenue for modern ceramic art education in China (see cat. no. 21).

Modern ceramics education in Jingdezhen has been a huge success in many aspects, including the break-up of traditional modes such as the passing of skills from master to apprentice; change of the knowledge base and structure of Jingdezhen for new generations of ceramic artists; and the encouragement of numerous new ceramic designers as well as artists. This period can be considered the fertile ground from which modern Chinese ceramic art developed.

Wang Xiliang (1922–), a nephew of Wang Dafan (one of the Eight Friends of Mount Zhu), exemplifies the change in educational mode. He began to learn ceramic art as a child from his uncle. In 1954, he entered the Light Industry Administration Ceramic Industry Science Research Center, which was established in Jingdezhen after the founding of New China, and worked in ceramic art creation and research. Here, Wang came to be influenced by the practices of contemporary fine arts, and he reformed his approach in his middle age. Going back to the foundations of painting, he practiced sketching and penetrated into life, learning from nature and the strengths of other people. In this way, his work inherited the style and expressive approach of the Eight Friends of Mount Zhu, while adding new painting elements. Wang Xiliang's work (cat. nos. 15 & 16), for want of space in this exhibition, must stand as representative of the numerous ceramic artists who have sprung up in today's Jingdezhen and successfully combined tradition and innovation.

THE MODERN CONTEXT: A REJECTION OF TRADITION

During the last one hundred years of development in Jingdezhen, the struggle between tradition and modernization was clearly evident. Both the Nationalist and the Communist governments, though at different times and with different political systems, wanted to replace traditional handicraft workshops with more modernized organizations and to displace traditional methods of teaching, such as the transmission of knowledge from masters to apprentices, with modern education. Rebellion against and criticism of tradition was the general trend.

The development of modern ceramics in China involved a kind of process that went from rejecting tradition to accepting it. Since the end of the 1980s, China has speeded up modernization with policies of openness and globalization. In this period, young Chinese ceramic artists became the first generation to receive a thorough introduction to modern Western art forms. Groups of artists referring to themselves as "modern ceramicists" emerged, finding their motivation in the key terms of rebellion and individuality. To them, "rebellion" means the liberation of ceramic art from its traditional utilitarian character and from the category of arts and crafts. The use of the term *xiandai taoyi*, or "modern ceramic art," is intended to redefine the concept of a ceramic artist while establishing a new ceramic language, one which is expressive, individual, and innovative in both concept and form.

These young artists broke down the traditional concepts of decorative style and modeling found in ceramic arts, focusing instead on the formation of new approaches, new materials, and abstract forms of installation. Due to the particularities of the ceramic material, there was a proliferation of modes of expression that was similar to that of other modern art forms which later became more experimental in nature. Modern ceramic artists have expanded the aesthetics found in traditional ceramics by introducing works that are rough, incomplete, fragmentary, and even unfired and techniques such as cutting, scratching, and carving. Their approaches include reflections on and criticism of society, as well as visual symbols that are incorporated according to personal preference and meaning. In this period, modern ceramicists rejected many Jingdezhen traditional techniques, and even the city itself became a symbol of conservatism and resistance to change. Local youths, including graduates of the Jingdezhen Ceramic Institute, left Jingdezhen one after the other, seeking their careers in more metropolitan areas.

THE POST-MODERN PERIOD: CHANGE AND RECONSTRUCTION

Since 2000, the structures of international politics, economy, and culture have changed greatly. In many places around the world, cultural traditions and heritage of the people have become resources used to construct and arouse the nation's political and cultural consciousness in the context of globalization. Meanwhile, cultural heritage has also been used as a way to create economic opportunities for local communities, serving to reinvigorate local culture and to stimulate economic growth on the local level.

Something similar has taken place in China. In the process of learning about the West and rebelling against tradition, artists and other intellectuals have found it unnecessary to abandon tradition but possible to reconstruct tradition in a modern way. Traditional symbols have taken on new charm in this age of reconstruction. As a result, Jingdezhen has again become a place for experimentation in the creation of new art, but not only for graduates of the Jingdezhen Ceramic Institute. Students from fine arts academies across the nation and artists from other areas of China and abroad who are interested in ceramic materials have all focused on Jingdezhen. The center's greatest attraction is not its ceramic history, its culture, the variety of glazes available, or the quality of its porcelain clay, but the cheap labor and skilled ceramic craftsmen (fig. 6). Though technique is not the most important aspect of modern art, its use can give birth to creative inspiration as well as increase the degree of freedom in art production. The once-closed and abandoned Jingdezhen State Porcelain Factory has attracted artists, art centers, and art studios, essentially becoming a modern ceramics center, something akin to the 798 Art District in Beijing. In other words, tradition in Jingdezhen is no longer a hindrance, but has become a resource for artistic creation.

Jingdezhen's traditional ceramics were mostly utilitarian porcelains, but since the founding of the Republic of China in 1911, makers have been trying to create something closer to art. They focused on ceramics decoration, mainly ceramic painting. The generation of artists who came of age after the

period of economic reform and openness surpassed their predecessors not only in their understanding of materials and firing, but by instigating a transformation in expression through space and content.

Zhu Legeng (b. 1952) is an example of this type of artist. He was raised in Jingdezhen and tutored by Shi Yuren. He then worked in the Jingdezhen Ceramic Institute and was later assigned to the Chinese National Academy of Arts as director of its Art Creation Center. Despite residing in Beijing,

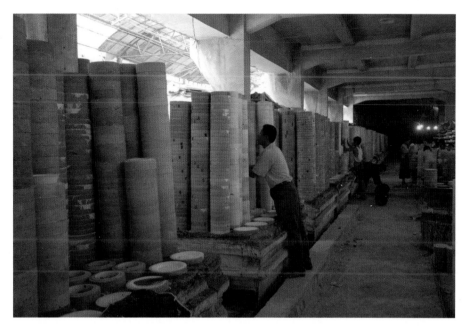

Fig. 6. The Guangming Porcelain Factory in Jingdezhen

he decided to set up his studio in Jingdezhen on the site of the Song dynasty Hutian kiln, famous for its *qingbai* (bluish-white) wares. This has required him to commute frequently between Beijing and Jingdezhen. Zhu's most representative works are ceramic mural installations, such as the series of works made for the Milal Concert Hall in Seoul, Korea: *Free Imagination in Time and Space, Light of Life, Mountain Clouds and Mists, Moonlight, Happy Times,* and others. His murals in China include *Comfortable Gentle Breeze,* made for the Shanghai Pudong International Airport; *Lotus,* made for the People's Square in Jiujiang; and *Golden Time,* made for the Raj Hotel in Tianjin. Such works broke the Chinese tradition that interior ceramic art is limited to free-standing pieces and introduced ceramics into public spaces and architectural environments. This is why his works are enormous and his concepts distant from traditional Jingdezhen ceramic art. In this exhibition, his work *Zen (Chan yi)* represents a group of meditating persons, each holding a lotus (cat. no. 22). The tops of their heads are open and glazed gold on the inside while the outside of the heads and the bodies are white. Here, the artist aimed to express the intangible nature and freedom of human ideas; the golden color, also on the interior of the lotus blossom or leaf, represents the preciousness of those ideas. Furthermore, the lotus is a Buddhist symbol, and the group of lotus-holding meditators is a metaphor of the restrained and introspective mode of thought in the East. Also in the exhibition, *Nirvana* (cat. no. 23) represents the meditators' minds surging and flying through the universe, transcending time and space, to reach a new realm. The work expresses transcendence and rebirth—the meaning of "nirvana." Zhu Legeng's masterpiece *Heavenly Horse (Tianma)* uses the subtle qualities of *qingbai* glaze to express a kind of spiritual realm.

Works by the artist Lu Bin (1961–), a professor of ceramics at Nanjing University, are also on display in the exhibition. Lu graduated in 1988 from Nanjing Arts Institute, where he majored in ceramics. He is among the most highly-respected ceramists in China today. All his works display an intense consciousness of Chinese culture and a sense of history, works such as *Compass* and *Movable-type Printing,* among others. He has also come to Jingdezhen in recent years to create works of art. His *Fossil 2004 III* (cat. no. 29) is part of a series of works consisting of complete cobalt-blue-decorated vases or broken objects pieced together from ancient and modern shards produced in Jingdezhen. Through these works—imitation "fossils" from a kind of "fictional history"

of Jingdezhen—he conveys an interesting idea: namely, that all things from the past and present will combine to become the history of the future.

Presently gathered in Jingdezhen are not only artists and students from various cities in mainland China, but also ceramic artists from other Chinese districts like Hong Kong and Taiwan. Zheng Yi (Caroline Yi Cheng), for example, is an artist from Hong Kong who has studied in America. When she came to Jingdezhen, she not only made her own artworks, but also began the Pottery Workshop (Letian taoshe). The Pottery Workshop was established in Hong Kong in 1985 for the purpose of providing space for artists and people who love pottery to produce and appreciate ceramics. Under Zheng's management, the Workshop grew to become the biggest ceramics center in Hong Kong. In 2002, the Pottery Workshop founded a new studio and exhibition hall in Shanghai's "art street" on Taikang Road and, in 2005, a new Pottery Workshop was established in the Jingdezhen Sculpture Factory district.

The Jingdezhen Sculpture Factory is now becoming "a ceramics 798." Established in 1956, it had more than fifty years of history. The old state-run factory was reformed under the slogan "State-run Step Back, Private-enterprise Step Forward." Under the new approach, the old buildings were rented by private enterprises and individuals, including high-profile artists and a range of workshops. In 2005, the Pottery Workshop arrived. The total area of the Factory, consisting of studios, experimental factories, galleries, shops, cafés, and artists' residences, is over one thousand square meters. There are almost eighty so-called Ceramic Creation Bases founded by celebrity studios, artist studios, and other institutions located in the Sculpture Factory. The Pottery Workshop is the largest studio in the Sculpture Factory, hosting numerous artists from all over the world to create ceramics every year.

The elaborate division of ceramic craftsman labor is a great attraction to artists. Martina, a resident artist from Austria at the Pottery Workshop, has been quoted as saying: "You can find any kind of craftsman you need, and they are very adept in their specialties. From throwing, trimming to glazing, painting, they are able to help artists turn their original ideas into actual works." She added, "Jingdezhen is a mysterious place; it possesses ceramic techniques I had never seen before. I feel so lucky to be here."[6] A student named Barbara, from the Dickinson Institute in the United States, completed her work *Blue Scenery* with the help of one hundred and one painters in Jingdezhen. She said, "Without Jingdezhen, my project [would be] a 'mission impossible'!"[7] According to Zheng Yi, the director of the Pottery Workshop, "artists often have ideas but lack the necessary skills; Jingdezhen craftsmen are just the other way around."[8]

The most representative of Zheng Yi's work in this exhibition is *Prosperity* (cat. no. 25), one of her "Butterfly Dresses." These are large-scale *hanfu* (Chinese traditional costume) pieces, each decorated with thousands of ceramic butterflies. Each butterfly is uniquely hand molded by local craftswomen in Jingdezhen. Every costume is decorated with between five thousand and twenty-five thousand butterflies. Only Jingdezhen craftspeople have such exquisite craft skills. Without Jingdezhen's environment and skilled workers, pieces like these could never be created.

THE "HOLY LAND" OF CERAMISTS

Throughout history, Jingdezhen was a city where "craftsmen come from all over the country and ceramics go all over the world." The Jingdezhen Contemporary Ceramics Exhibition demonstrates that the same situation exists today. But the difference now is that both Chinese and foreign artists come to Jingdezhen. It is the traditional ceramic culture and techniques that attract them.

Ah Xian (1960–), an artist who had been living in Australia beginning in the 1990s, came to Jingdezhen at the end of that decade to create works of art. A characteristic feature of his work is the use

of real people as subject models for busts (see cat. nos. 44–47), created with rollover molds, which are then completely decorated with traditional Chinese auspicious patterns or landscape paintings in *famille-rose* enamels or cobalt blue. This obscures the faces of the portraits. The artist thus uses two-dimensional planes to break up the three-dimensional space and eliminates the original significance of the traditional decorative patterns. These characteristics impart a feeling that is at the same time traditional and modern, and the mixture of various skills and cultural elements is refreshing. The concept and the modeling of the sculptures were executed entirely by Ah Xian himself, while the decorative patterns were completed by Jingdezhen craftsmen, whose traditional yet exquisite skills add an important historical aspect to the works.

Sin-ying Ho (1963–) is a ceramics professor at the City University of New York. In the late 1990s, she studied at the Jingdezhen Ceramic Institute and has since come to Jingdezhen frequently to create ceramic works. Most of her pieces are huge in size and decorated with symbols combining traditional cobalt-blue decoration with decal printing (see cat. nos. 26–28). Her work focuses on cultural collisions and collaborations between East and West and between tradition and modernity in a globalized world. As with others mentioned here, her vision would be hard to realize without the exquisite skills of Jingdezhen craftsmen. In any other place, the gigantic pieces of high-fired porcelain or the complex blue-and-white decoration would be impossible to achieve.

Zhao Meng (1967–) graduated from the Chinese National Academy of Art in 1992 and has been working long term in Harvard University's Ceramics Studio since 2002. In recent years, since finding inspiration and establishing his own studio in Jingdezhen, Zhao works for long periods there. The pieces chosen for this exhibition (cat. nos. 31–36) come from his series of *linglongshi* (literally, "exquisite stones"). As products of nature, having been scoured by water and air, these stones have profound connotations in Chinese culture. For over a thousand years, Chinese literati chose the ones they considered beautiful for display in their courtyard, in the living room, and on their desk in the study. They are found in every corner of Chinese daily life, especially in that of the literati. Zhao Meng uses Jingdezhen's plastic kaolin clay to reproduce the exquisite stone, which has been silent yet full of meaning in the Chinese literati's life for more than a thousand of years.

The eldest artist in the exhibition is Zhu Dequn (Chu Teh-Chun; 1920–), a Taiwanese-Frenchman. As an oil painter, he blends Chinese ink painting and Western abstract painting, earning him praise as "the most successful painter [to] integrate the exquisite Oriental art and strong Western painting."[9] Although living abroad long term, Zhu has been concerned about Chinese culture all along. The four works by Zhu in this exhibition are part of a series called *Of Snow, Gold, and Sky Blue*, which was produced in The Manufacture Nationale de Sèvres in his later years. Established in Sèvres in 1760 during the reign of Louis XIV (1715–74), the manufactory employed techniques that initially came from Jingdezhen, especially that of blue-and-white decoration. Zhu began creating ceramic art at the age of nearly ninety years, a clear manifestation of his return to Chinese culture, since porcelain has always been its most distinctive art. Unlike his practice as an oil painter, the use of cobalt-blue paint on ceramics meant that he had to transmit his idea onto a demanding material without hesitating or alteration. He had to paint quickly but also show the characteristics of the ceramic material. As a result, he created his own style. Zhu's ceramic works were mainly decorated in cobalt blue. At the center of his painting style are dynamic, dissolving, and vanishing shapes in variegated tones of blue integrated with rapidly drawn lines and pointed dabs; the piece is then decorated with gold to produce a bright and splendid coloration. Through Zhu's ceramic art, we can see that there are derivatives of Jingdezhen's ceramic art in every region of the world, especially in Europe.

In the sixteenth century, Europeans began to purchase ceramics in Jingdezhen, and by the eighteenth century they established their own ceramic factories. After taking the lead in today's ceramic art field throughout the world, European ceramic factories still retained the blue and white that is most characteristic of Jingdezhen ware. Now, after Zhu's developments, they have what are the most representative colors in his ceramic works—blue and gold.

In addition to the aforementioned ethnic Chinese

Fig. 7. Young college students and young ceramic artists who had established their studios in Jingdezhen hold exhibitions of their artworks in the yard of the Letian Pottery Workshop every Saturday

artists living in various countries, there are also foreign-born artists who are working in Jingdezhen long term to create ceramics. Works by American artist Wayne Higby have been chosen for this exhibition. Higby is a professor at the New York State College of Ceramics at Alfred University. He is also one of the earliest artists to come to Jingdezhen for academic exchange and ceramic creation. In June of 1992, he was invited to give a lecture at the Jingdezhen Ceramics Institute, and the brief two days he spent in Jingdezhen changed his life. From then on, he has regularly traveled between Jingdezhen and America, wondering if he even might have been a native of Jingdezhen in a previous life. He had been creating works using stoneware clay until he came to Jingdezhen and discovered the unique charm of kaolin, a material he investigated several times at its original source—Gaoling Village near Jingdezhen. Subsequently, he started to use kaolin for creating his own ceramics. Although his works are created in America, what he pursues is the effect of Jingdezhen's *qingbai* porcelain from the Song dynasty.

Jingdezhen's traditional ceramic techniques have had a great influence on ceramists around the world. They include Ole Lislerud from Norway, who likes to make huge ceramic murals and, in Jingdezhen, felt like a fish returned to water. He says, "I respect the history of Jingdezhen and its unique craftmanship which cannot be found elsewhere in the world. Vessels five meters high and porcelain plaques three meters in length are impressive documentation of this knowledge and craftmanship. But the essence of art is change, and in this perspective ceramic artists in Jingdezhen seem to uphold their traditions, repeating yesterday's history rather than experimenting with new concepts. However there are exceptions to this observation, like the artist Liu Jinhua."[10] Even so, such repetition might be necessary, since that is exactly how the traditional skills were honed to their current extremely high level. It is, after all, those high skills that have enabled outside artists to realize their creative dreams.

Professor Li Renzheng from Hongik University in Korea was asked by this writer why he brought students to Jingdezhen to make ceramics. He replied that when he studied in Japan as a young man, he thought Japan had the most abundant ceramic skills and glazes. But when he came to Jingdezhen, he realized he was wrong. Moreover, he asserted that if you asked any ceramist in any country where he or she most wants to go, ninety percent of them would say "Jingdezhen." Jingdezhen has truly become the "Holy Land" for ceramists.

The Dreamland of Youth

In the wake of developments in Chinese society, the composition of Jingdezhen craftsmen has changed rapidly. Some still come through traditional local channels, but others are graduates of various art institutes around China. These graduates would settle down in Jingdezhen, establish their studios, and find positions through which they can orient their development. Every Friday night, famous ceramists from different countries are invited to give lectures at the Pottery Workshop. In Sanbao Village near Jingdezhen, ceramists of different nationalities gather and make ceramics. Every year, the Jingdezhen Municipal Government holds a Ceramic Fair and International Ceramics Exhibition. These developments have created an international atmosphere for the art school graduates. At the same time, Jingdezhen's history and traditions, together with its raw materials (such as kaolin) and its high-quality craftsmanship, feed their enthusiasm for the ceramics profession. Most importantly, their works have a vast market in China's new urban economic life. These young workers make porcelain art as well as ceramics for a new way of living and new city architecture. They are the most hopeful new generation of Jingdezhen (fig. 7).

Beijing's 798 Art District has become the focus for numerous contemporary Chinese artists known for their provocative ideas and distinctive characteristics. Similarly, Jingdezhen, the capital of traditional ceramics, has become an "incubator" where the inspirations and dreams of ceramists from all over the world are aroused and realized. This kind of space was created by outside artists and local craftspeople working together. It is a cultural phenomenon that has never before happened in history and a significant component in the reconstruction of culture and art in an era of globalization.

Notes

1. Jingdezhen shi zhilue bianzuan weiyuanhui, ed., *Jingdezhen shi zhilue* 景德镇市志略 [*Records of Jingdezhen city*] (Shanghai: Hanyu da cidian chubanshe, 1989), p. 7.

2. Wang Shimao 王世懋, *Eryou weitan* 二酉委譚, in *Jilu huibian* 纪录汇编 (Shanghai: Shanghai Commercial Press, 1938), *juan* 206.

3. *Fuliangxian zhi* 浮梁县志 [Gazetteer of Fuliang county] (China: n. p., Qianlong 48th year [1783]), *juan* 1.

4. *Fuliangxian zhi*, juan 12, "Zaji" 杂记 [Miscellanies].

5. Peng Yuxin 彭雨新 et al., ed., *Zhongguo fengjian shehuijingji shi* 中国封建社会经济史 [History of China's feudal society] (Wuhan: Wuhan daxue chubanse, 1994), p. 410.

6. "Jingdezhen: Haineiwai taoyijia 'fuhua' yishu linggan yu mengxiang" 景德镇：海内外陶艺家"孵化"艺术灵感与梦想 [Jingdezhen: Incubator of artistic inspiration and dreams for potters at home and abroad], *News QQ*, October 20, 2008, http://news.qq.com/a/20081020/000798.htm. No surname is given for Martina (玛蒂娜).

7. Shen Yang 沈洋 et al., "Qiannian cidu weihe yige shijieji taoci pinpai" 千年瓷都为何没一个世界级陶瓷品牌 [Why is the thousand-year-old Porcelain Capital not a world-class ceramic brand name?" *Xinhua*, October 22, 2008, http://news.xinhuanet.com/focus/2008-10/22/content_10231719.htm. No surname is given for Barbara (芭芭拉).

8. Ibid.

9. "Zaoqi youhua shi da mingjia jiazhi bang" 早期油画十大名家价值榜 [A list of values for the ten great masters of oil painting in the early period], *Sina Collection*, September 9, 2011, http://collection.sina.com.cn/yhds/20110921/101439303.shtml.

10. Ole Lislerud's statement, sent in a personal communication to the author, is a revision of the original statement that had been translated into Chinese and quoted in an interview by Zhang Ganlin 张甘霖, "Nuowei yaoyijia Wula yu Zhang Ganlin" 挪威陶艺家乌拉与张甘霖的对话 [A conversation between Norwegian ceramist Ole (Lislerud) and Zhang Ganlin], in Blog.Artron.Net, posted February 17, 2010, http://blog.artron.net/space.php?uid=68313&do=blog&id=347295.

景德镇与艺术家：1910～2012

方李莉

一、引言

在中国有一个词叫"北漂"，意思是很多年轻人抱着美好的梦想，到北京发展自己的事业，哪怕一时没有正式的工作，人们也愿意在这里漂着。北京是中国的首都，是全国的文化、政治、经济中心，是年轻人梦想和灵感的孵化地。但现在人们可以听到一个新的单词叫"景漂"，也就是说，有许多毕业于各地美术学院的年轻学生们，年轻的艺术家们来到景德镇，在这里开设艺术和设计工作室，寻找着自己新的梦想。景德镇是一座有着千年制瓷历史的古都，但今天它却以一种年轻的充满着新的生机的步伐向我们走来，因为哪里有年青人哪里就有新的希望，哪里就有新的生命力。而景德镇新的希望和新的生命力来自哪里？这是值得探讨的，也是这次展览策划要表达的主题。

二、景德镇的地理位置与自然资源

景德镇市位于江西省的东北部。境地东接安徽省休宁和本省婺源、德兴；南邻万年、弋阳；西连鄱阳；北与东北同安徽省的祁门毗连。市区距省会南昌249公里，距海岸线302公里（注1）。景德镇四周属于丘陵地带，城区坐落在群山环绕的小盆地中，周围群山环峙、一泓昌江水，上溯安徽祁门，下接鄱阳湖，城区就在碧水涟漪的昌江两岸。江水穿城而过，还有南河环绕于东南，两河贯穿于两岸，形成三水环城之势。景德镇街市沿昌江由北向南呈一字形长龙阵，长达十三里。（插图一，《景德镇附近的丘陵地带》方李莉摄［参见英文插图］）

景德镇四面环山，山里盛产木材，其以前的所属地浮梁县以及周围各县有丰富的森林资源，尤以松树、杉树为主要树种，而且长满了一种被当地人称为狼鸡草的蕨类，这些都是景德镇烧瓷、制瓷的主要燃料和材料。另外附近的麻仓山、高岭山、东乡、余干、乐平、星子、祁门等地都盛产瓷土、耐火土等制瓷原料，流经景德镇城区的昌江河，是景德镇城市的动脉，昌江下游河道水流平缓，流域内多古老变质岩区，岩层质坚，侵蚀较轻，河床也较稳定，河水含沙量甚微，冲淤现象不明显，故水质、水量都适宜于瓷业生产，除了东河、南河、西河、小北河、梅湖河、建溪河各条支流呈叶脉状分布，由东西分别流入外，还有五十多条小支流，形成纵横交错的河网（参见本图录第 xxiv 页《景德镇古代窑址和水系图》转引自方李莉著《景德镇民窑》，人民出版社2003年版，第16页）。

这些以昌江为主流的大小河流，给景德镇的瓷业生产、销售、运输带来了许多方便。其一是确保了瓷业用水，河水不仅可供淘洗瓷土，而且可以利用流水落差作动力，装置水轮车和水碓，用以粉碎瓷石。其二是提供了水上运输，当年的昌江河可通木筏、木船，景德镇主要依靠它们输入制瓷原料、燃料、农副产品，运出陶瓷产品。

明清时期，景德镇制瓷业的旺盛所带来的繁荣富庶，历数百年不衰。明代文学家王世懋对明代中晚期的景德镇有过生动形象的记述。他说："天下窑所聚，其民繁富，甲于一省"。"万杵之声殷地，火光烛天，夜令人不能寝，戏目之曰：'四时雷电镇'"（注2）。从王世懋短短的几句话中，我们看到了明中晚期景德镇的繁荣。瓷土的捶打声、烧造瓷器的冲天火光，使整个景德镇形同一个巨大的手工工场，一个震耳耀目的制瓷工地。1728年（雍正六年）督陶官唐英在回顾景德镇的盛况时，也曾说："其人之居稠密，商贾之喧阗，市井之错综，物类之荟萃，几与通都大邑"（注3）。

因为在历史上沿河置窑，沿窑成市，所以景德镇街市的走向与昌江的流向一致，由此向南，纵列式地发展。北起自观音阁，江南雄镇坊，经前街后街，至小港咀，直抵南河口。而东西之间，宽处一二公里，窄处仅0.5公里。呈一字长蛇阵，整个市区为不规则的长条形，完全是随着陶业的发展而形成的，并且也是工商业都市依靠水路运输而自然形成的明显特征。（插图二，景德镇昌江方李莉摄于1995年;插图三，清嘉庆景德镇街市图转引自方李莉著《景德镇民窑》，人民出版社2003年版，第20页［参见英文插图］）

三、景德镇陶瓷历史

据历史记载："新平冶陶，始于汉世"（注4）。新平镇是景德镇最早的名称。虽然古文献中尚没有发现关于景德镇唐代和五代陶瓷业发展的记述，但其众多的古窑址为现代人研究五代的景德镇民窑的发展状况提供了线索，据近年来的调查，景德镇发现唐代窑址和五代窑址十几处，主要分布在南河两岸和现今的市区范围。

（插图四，景德镇五代陶瓷遗址，方李莉摄［参见英文插图］）

宋代的经济发展促进了中国的陶瓷生产，当时大江南北名窑倍出，而在五代已初露头角的景德镇窑场出现了村村窑火、家家埏陶的繁荣场景。宋代景德镇烧造的是青白瓷，晶莹如玉，受到当时皇帝的青睐，让其为皇宫烧制贡瓷，而景德镇置镇与得名正是始于此时。据明清历届《江西通志》谓："宋景德中置镇。始遣官制瓷贡京师，应官府之需，命陶工书建年'景德'于器"。于是"天下咸称景德镇，而昌南之名遂徽"（注5），从那时到现在，近千年来，景德镇的名字沿用至今。

元代由于景德镇当时生产的白瓷受到统治者的青睐，故在景德镇设立了为统治者提供御瓷的管理机构。同时生产出了划时代的青花瓷，使其在中国的陶瓷界有了很大的影响。

明朝初年皇家在景德镇创建御器厂，一直延续到清朝末年，长达五百年之久。这种御器厂就是为皇帝造瓷的工场机构，景德镇从宋代就开始为皇帝造瓷，但在当时的景德镇并没有真正的官窑，只是在皇帝有命令时才烧造，没有命令时，则只是民间自己为市场的需要制瓷。但明清以后皇家正式在景德镇建造官窑，由于这里的土质优良，在元代时出现的青花瓷受到海内外市场的青睐，加上皇帝的官窑建造在此地，对当地陶工们的制瓷技术提出了非常高的要求。于是景德镇的名声大振，不仅是各地的国内市场，还有不同国家的商队也通过各种渠道来景德镇购买瓷器。使其不仅成为了中国的制瓷中心，也成为了世界的制瓷中心。从十五世纪到十九世纪上叶，景德镇的瓷器大量输出到世界各国，尤其是欧洲，其精美的陶瓷曾深刻的影响了世界的文化和艺术的发展。（插图五，《景德镇清代官窑图》转引自方李莉著《景德镇民窑》，人民出版社2003年版，第105页［参见英文插图］）

四、中国百年的蜕化与追求

从十九世纪末开始，中国遭遇了一场从农业文明向工业文明的巨大转型，而类似景德镇这样古老的手工业城市的发展也面临了巨大的挑战。于是，中国花了一百余年时间从一个古老传统的国家蜕化成为一个新的现代化国家，笔者将这一过程分为三个不同的阶段：1、民国时期，为早期现代化时期（1911～1949）；2、新中国建立至改革开放中后期（1949～2000年），为中期现代化时期；3、改革开放后期至今（2000年至今），为后期现代化时期。

在这三个不同的历史时期，人们对于传统与现代化的关系是具有不同的认识的，这不同的认识导致了景德镇这座千年古镇的不同发展模式，甚至影响了不同时期的景德镇艺术的创作风格。

由华美协进社中国美术馆举办的《新瓷——景德镇的百年瓷艺，1910～2012》展览，就是希望通过不同时期的陶艺家们在景德镇当地所做的作品来展示景德镇百余年来的文化变迁。为此，这次展览一共分为四个部分，第一个部分是民国时期（早期现代化）的景德镇文人艺人的作品，第二个部分是计划经济时期（中期现代化）传播现代化教育的陶瓷学院教授的作品，第三部分是改革开放以后，即后期现代化时期，来自国内不同城市和地区艺术家在景德镇创作的作品，第四部分是来自不同国家的华裔或外国籍艺术家在景德镇创作的作品。由于展厅的局限性，每一个时期只能选择极少数代表性人物的作品，展览虽然表达的是历史，但为了突出"新"，所以主要以新的后现代化时期的作品为主。以下笔者将对近百年景德镇的历史变迁及展的内容做一个大的勾勒与描述。

五、以"传统"挑战"现代"

二十世纪初至中叶，也就是民国时期，景德镇面临一个前所未有的从传统到现代转型的挑战，即由手工艺生产转向机械化生产，其意味着景德镇千百年积累下来的手工艺技术与经验一夜之间面临淘汰的危险。为了应对现代化的挑战，景德镇民间社会一方面害怕新的现代化技术和知识系统会取代自己传统的技艺与知识系统，所以

首先从制度上抵制现代化。但另一方面又意识到墨守成规是没有出路的，必须进行技艺方面的革新。于是，一部分艺人产生了强烈的自我意识。他们开始试图在瓷器上表达绘画艺术，同时也试图追求和画家同等的地位。

在中国的历史上，文人有群体，画家有画派，但陶瓷工匠，由于地位低微，所以，尽管景德镇的瓷器誉满全球，但制作这些瓷器工匠们的名字却鲜为人知，他们的身份只是受雇的工匠和劳动者，几乎没有结社的可能性和条件。但此时，面临内忧外患，他们自动的聚集在一起结社，并形成群体。其中最有代表性的群体是"月圆会"，于1928年由王琦等人发起成立，取花好月圆人寿之意每逢农历十五日集会一次，成员轮流作东道主集会时，每人带一件新作到主人家共同欣赏观摩，饮酒吟诗作画。他们这个群体还有一个称呼就是"珠山八友"，叫八友实则是十个人，这并不前后矛盾。正如"江西诗派"也并不全是"江西人"，景德镇"五彩瓷"也并不只有五种颜色一样。

"珠山八友"虽然是陶瓷工匠，但大都是受过一定教育，如邓碧珊、毕伯涛是清末秀才，田鹤仙是江西省瓷业公司夜校教员，汪野亭、刘雨岑毕业于鄱阳江西省甲种工业窑业学校饰瓷科。他们是当时景德镇民间艺人们中的改革先锋，是景德镇最早把自己的名字写在陶瓷作品上，最早把陶瓷作为一种艺术来创作的群体。

为了再现这段历史，策划者选择了"珠山八友"十位艺术家的每人一件瓷板绘画作为展品。这些瓷板画的尺寸都很小，但画得很精致，基本是采用景德镇当时流行的传统粉彩瓷技艺画成。粉彩瓷的技法始创于康熙，极盛于雍正。由于受官窑的推崇，自其成熟以来，就成为景德镇陶瓷装饰的主流。珠山八友们试图运用这一技法在陶瓷绘画上追求中国画的效果与意境，这是当时景德镇的一个主要审美导向。

虽然从清代以来在景德镇流行的主要是粉彩瓷，但青花瓷仍然受到市场的欢迎。景德镇的青花瓷成熟于元至正年（1341年）左右，自其成熟以来一直是景德镇最重要的生产品种，从明万历年（1563年）开始到清中期，中国出口到欧洲的大多是青花瓷。几百年的烧制与研究，到民国时期，景德镇青花瓷的绘制技艺已达到很高的成就。所以这次展览中，还选择了当时被称为"青花王"的王步（1898年～1968年）的一对青花花鸟瓶和一件青花笔筒，作品虽然不大，但画得非常精彩。

从以上的这些作品中，我们可以看到民国时期的景德镇的部分文人艺人们，他们不再甘愿认同工匠的身份，而开始追求艺术家的身份和地位，他们不仅在陶瓷上绘画，还写诗和练习书法，包括篆刻金石等这一系列的文人画家的修养和技法，他们都在努力掌握。这些文人工匠的出现虽然没能把景德镇的陶瓷业从萧条中拯救出来，但却传承和发展了景德镇陶瓷的手工技艺，并为今天的景德镇传统技艺的复兴，以及为景德镇从一个日用瓷生产的中心转化为一个艺术瓷创作的中心打下了基础。

六、现代教育的兴起

自民国以后，政府为了面对现代化的挑战，首先采取的措施就是在景德镇建立新型企业，实行现代化的管理将整个国家纳入到世界工业化的体系中去；然而，新的体制需要新的人才，民国时期，国民党政府在景德镇附近的鄱阳县建立了江西省甲种工业窑业学校。新中国建立以后，在共产党领导下，于1958年窑业学校被改为景德镇陶瓷学院，成为中国唯一的一所陶瓷高等学校。现在这所高等学校为中国培养了众多的具有现代视野的陶瓷设计师及陶瓷艺术家，为景德镇的陶瓷艺术从传统向现代转型做出了贡献。

在这次展览中选择了三位景德镇陶瓷学院美术系教授的作品，一位是施于人教授，一位是周国桢教授，他们都是景德镇陶瓷学院的创办者，既是中国著名的陶瓷艺术家，又是著名的陶瓷艺术教育家。其中施于人教授（1928年～1998年），毕业于北京中央美术学院实用美术系。1955年，景德镇创办陶瓷美术技艺学校，施于人由国家高等教育部调配来景德镇任教。1958年成立景德镇陶瓷学院后，他受聘担任陶瓷设计方面的教授。他很喜欢民间的陶瓷艺术，一生研究五彩与红绿彩。由于教育背景不一样，其作品和景德镇当地的陶瓷艺人，有着完全不一样的风格。有着更强的装饰性及设计语言，同时也更具有现代感。

另一位周国桢教授（1931年～），1954年毕业于中央美院雕塑系，毕业后到景德镇陶瓷研究所工作，后来调入陶瓷学院美术系担任雕塑老师。景德镇有着深厚的陶瓷雕塑传统，但周国桢教授受现代美术教育的影响，将写生技巧融入到其雕塑创作中，并注重火与土的语言，为传统的景德镇陶瓷艺术带来了新的面貌。

还有一位姚永康教授（1942～），是比施于人和周国桢晚一辈的陶瓷学院美术系的教授，于1966年景德

镇陶瓷学院美术系毕业。后在景德镇陶瓷学院担任雕塑专业的教学工作，他自创现代泥片卷塑技法，使他的作品与景德镇的传统拉开了距离，开辟了中国现代陶瓷艺术教育的先河。陶瓷学院的教育打破了陶瓷工匠师傅教徒弟的教育方式，现代教育改变了新一代景德镇陶瓷艺术家的知识背景与知识结构，也造就了许多新的陶瓷设计师与陶瓷艺术家。可以说是中国现代陶瓷艺术发展的温床。

七、现代语境中：对传统的排斥

在景德镇近百年的发展中，我们可以看到：在早期现代化与中期现代化时期：传统与现代完全对立。无论是国民党政府还是共产党政府尽管他们的政治体制不一样，但都希望在景德镇建立新型的现代化企业来代替景德镇传统的手工艺作坊，而以现代教育来取代景德镇师傅带徒弟的传统教育方式。在这一时期，人们总的趋势是反叛传统和批判传统。

就包括中国的现代陶艺发展也经历过从对传统的排斥到相融这样一个过程。如从上世纪的80年代末开始，随着国门的打开及全球化的发展，加快了中国向现代化转型的速度，在这一过程中，年轻一代的中国陶瓷艺术家经受了西方现代主义艺术形式的全面洗礼，这一时期中国出现了以"现代陶艺"冠名的年轻群体，其关键词就是反叛与个性，所谓的反叛就是将陶瓷艺术从传统的实用性中，从工艺美术的范畴中解放出来，并用"现代陶艺"这样的词，重新界定陶瓷艺术的概念，同时建立一种表现性的，个人标识性的，以形式与观念的创新为主要目标的新的陶瓷语言。

他们打破传统陶瓷艺术中的装饰风格和造型观念，把讨论的焦点放在观念的形成，对材料的关注，以及装置的抽象形式等方面。由于陶瓷材料的特殊性，还有表现手法的丰富性，使其与现代主义艺术形式有许多不谋而合的地方，为此，也成为现代艺术的新的实验场地。现代陶艺扩充了传统陶艺的审美范畴，把粗砺、残缺、破碎，甚至非烧制的其它材料引入到陶艺，把各种切割、划痕、刻刮等肌理表现引入到陶艺，把对社会的思考和批判引入陶艺，把更具有个人特点的视觉符号引入陶艺。在这一阶段，这些现代陶艺家们看不起景德镇的传统技艺，就包括景德镇这座城市都成为了保守与一成不变的象征。这一时期当地的年轻人们，包括在景德镇陶瓷学院毕业的学生们都纷纷离开景德镇，到大城市去开拓自己的事业。

八、后现代语境中：变迁与重构

2000年以后，人类社会的政治结构、经济结构和文化结构发生了巨大的变化，在世界范围内的许多地方，民族的文化传统与文化遗产，正成为一种人文资源，被用来建构和产生在全球一体化语境中的民族政治和民族文化的主体意识，同时也被活用成当地的文化和经济的新的建构方式，不仅重新模塑了当地文化，也成为了当地新的经济的增长点。

而中国也一样，在学习西方和反叛传统的过程中，人们开始意识到了其实我们不用抛弃传统，我们可以用现代方式去重构传统，传统的符号在重构中展示出了新的魅力。于是，景德镇开始成为新艺术的试验地，不仅是景德镇陶瓷学院，还有全国各大美术院校的毕业生以及各地对陶瓷媒材感兴趣的，包括许多国内外的陶艺家们也前往景德镇集中。景德镇吸引大家的不仅是它的陶瓷历史和文化，它品种众多的釉料和瓷泥，更重要地是它有许多廉价的劳动力和技艺高超的陶瓷工匠。虽然现代艺术不再仅仅是技术，但技术也会带来新的创作灵感，包括新的创作自由度。以往关闭和废弃了的景德镇国营瓷厂，开始吸纳了众多的艺术家、艺术机构和艺术工作室。以此，形成了类似北京798的现代陶艺中心。也就是说景德镇的传统不再是一种束缚，而成为了一种新的艺术创作的资源。（插图六，《景德镇光明瓷厂》景德镇瓷业公司供稿［参见英文插图］）

景德镇传统的陶瓷器主要是日用瓷，即使从民国开始，景德镇的艺人们，就试图向艺术靠拢，在陶瓷装饰上做了许多的努力，但这种努力主要是表现在瓷器上的绘画。而新的一代成长于中国改革开放以后的现代陶艺家们，他们不仅在观念上，在对材质及火的认识上超越了前辈，就是在表现的空间和内容上，也有了巨大的变化。

以朱乐耕的作品为例，他生长于景德镇，是施于人教授所带的第一个硕士研究生，曾在景德镇陶瓷学院工作，后来被调入北京的中国艺术研究院担任艺术创作中心的主任。尽管如此，他仍然将自己的工作室建立在景

德镇宋代著名的陶瓷遗址湖田村，经常往返于北京和景德镇之间。他最有代表性的作品是为韩国首尔麦粒音乐厅所做的系列陶艺装置壁画如：《时间与空间的畅想》、《生命之光》、《山岚》、《月色》、《欢乐时光》等；为上海浦东机场所做的陶艺装置壁画《惠风和畅》；为九江市民广场所做的陶艺装置壁画"莲"，为天津瑞吉酒店所做的陶艺装置壁画《流金岁月》等。他的作品打破了陶瓷艺术室内陈设的传统，而进入了公共的环境建筑空间，正因为如此，他作品的体量非常大，与传统景德镇的陶瓷艺术的概念拉开了较大的距离。

另外，此次展览还选择了南京大学陆斌教授的作品，他于1988年毕业于南京艺术学院的陶艺专业，他是现当代中国非常活跃的陶艺家，他所有作品都具有非常强烈的中国文化意识和强烈的历史感。如作品"指南针"、"活字印刷"等。近年来他也不断地来到景德镇做作品，这次他展出的一组古代的和现代的景德镇生产的青花瓷瓶碎片，是他对景德镇历史场景的一种"模拟"，在作品中他试图让我们看到：所有过去的和现代的都会凝固成过去的和未来的历史，这是非常有意思的对于历史的思考。

目前在景德镇不仅聚集着来自中国大陆各省市的艺术家及年轻的学子们，还有来自港台不同地区的陶瓷艺术家。如郑祎是从香港来到景德镇的艺术家，她曾在美国受教育。她来到景德镇的意义不仅是自己在这里进行陶艺创作，更重要的是她把香港的乐天陶社带到了景德镇。乐天陶社于1985年创办，目的是为陶艺家和热爱陶艺的人士提供欣赏及制作陶瓷艺术空间。目前在陶艺家郑祎女士的统领下，已成为香港最大的陶艺中心。2002年乐天陶社在上海泰康路艺术街创立了新的工作室和展示厅；2005年在景德镇雕塑瓷厂成立了景德镇乐天陶社。

现被称为陶瓷"798"的前身是景德镇的雕塑瓷厂，这家有52年历史、曾辉煌一时的国营老厂以"国退民进"的方式进行了国有企业改革，原有的厂房被民营企业和私人租用，成为名人工作室和各类小作坊的聚集地。2005年，乐天陶社进驻景德镇雕塑瓷厂，其组成部分包括工作室、实验工厂、画廊、商店、咖啡馆和艺术家住所，总面积超过1000平方米。现在雕塑瓷厂内大约有近80家名人工作室、艺术家工作室和机构设立的陶瓷创作基地，而乐天陶社是其中最大的驻场工作室，每年都要接待不少来自世界各地的艺术家，在这里进行陶瓷艺术创作。

景德镇分工细致的陶瓷匠人对艺术家有着极大的吸引力。乐天陶社的驻厂陶艺家奥地利的玛蒂娜说："在这里你可以找到任何你需要的手艺人，他们对自己的领域非常精通，从拉坯、修坯，到上釉、绘画，他们可以帮助艺术家将最初的设想转变为成形的作品"。她还说"景德镇是一片神奇的土地，这里拥有我前所未见的陶瓷技术。我真庆幸自己可以来到这里"。美国狄更生学院的芭芭拉在景德镇101个画师的帮助下完成了作品蓝色风景线，她说："如果不是在景德镇，这是不可能完成的任务"。乐天陶社社长郑祎说，"陶艺家是有想法没办法，而景德镇的陶瓷工匠是有办法没想法"。

在这里最有代表性的是这次展出的郑祎的作品——《蝴蝶衣》，这是一件点缀有几千或几万只瓷塑小蝴蝶的大型汉服，小蝴蝶均由景德镇当地女工手工捏制而成，任何一只都独一无二。每件用瓷蝶5000只到25000只不等。这样的精湛手工技艺只有景德镇的工匠才能拥有，如果离开景德镇，离开景德镇工匠的陶瓷技艺，这样的作品是不可能制作得出来的。

九、世界陶艺家的"圣地"

景德镇在历史上就是"工匠来四方，器成天下走"的城市，这次展览的景德镇当代陶艺展也正是体现了这样的一种景况，不同的是在全球一体化的今天，来到景德镇的不再仅仅是中国境内的"四方工匠"，而是来自世界各国的艺术家们。是景德镇的传统陶瓷文化和技艺吸引了他们。

如旅澳艺术家阿仙，他于上世纪的九十年代来到景德镇做作品，他的作品特点是以真人翻模的半身胸像作为主体造型，全身满绘传统的粉彩、青花等中国传统吉祥图案，或山水绘画，使得人物的五官变得模糊难辨，用二维的平面图案破坏三维的空间，消除了传统装饰图案的原始意义，让人觉得既传统又现代，各种技巧和各种文化元素的混杂，给人一种耳目一新的感觉。在这里，整个作品的理念和雕塑的造型是由他自己完成的，但装饰在雕塑上的各种青花的，粉彩的装饰画面及图案却是由景德镇的工匠们完成的，工匠传统而精湛的手艺给作品增添了许多历史性的想象空间。

陶艺家何善颖是纽约城市大学的陶艺教授，上世纪九十年代末，她曾在景德镇陶瓷学院学习，自那以后，她就经常来到景德镇做作品，她的作品大多是以景德镇传统的青花结合花纸印刷的手法，在巨大的器皿造型上，

表现各种以在全球化背景中东西方文化以及传统与现代文化的相互碰撞和交融为主题的图像符号。何善颖的作品与前面几位陶艺家的作品一样，如果没有当地工匠的精湛技艺，是很难完成她所达到的效果的。无论是那硕大的高温瓷的造型，还是复杂的青花瓷工艺都是在景德镇以外的地方难以完成的。

旅美陶艺家赵勋，长期在美国哈佛大学的陶艺工作室工作，近年他在景德镇找到了灵感，并找到了自己的创作空间，他不断地往返于景德镇和纽约之间，其实除了不同国籍的中国的陶艺家之外，还有长期在景德镇做陶艺创作的不同国家的艺术家，这次展览还选择了美国陶艺家温·海格比的作品，他是纽约阿尔佛雷德陶瓷学院的教授，是最早到景德镇做学术交流及陶艺创作的外国陶艺家之一。1992年6月，应邀到景德镇陶瓷学院举办学术讲座，受到陶院师生的欢迎。在景德镇讲学的短暂两天，成了他生活中的一个转折点。以后他多次往返于美国和景德镇之间，他甚至认为自己前生就是景德镇人。在来到景德镇之前，他一直用陶土做作品，到景德镇以后，他发现了高温瓷泥所独具的魅力，还特地多次到高岭土的原产地高岭村做考察。以后他开始用高岭土做作品，这些作品虽然是在美国完成的，但他追求的却是景德镇宋代影青瓷的效果。

景德镇传统的陶瓷技艺影响了世界众多的陶艺家，如挪威陶艺家乌拉once喜欢做巨大的瓷板壁画，来到景德镇后他如鱼得水，并说道"我非常尊重景德镇的历史，它拥有的技艺，是世界上任何其它地方都没有的，它做得出几米高的瓷瓶，几米长的瓷板，而我觉得奇怪的是，为什么景德镇当地的艺术家没有好好地利用这些好的技艺，很少有人有新的想法，而一直都是在重复昨天的历史"。不过也许这些重复也是需要的，因为如果没有这些工匠们的重复劳动及将传统的技艺推到极致，这些外来的艺术家们的许多新的创作就难以得到实现。

策展人曾采访过来自韩国弘益大学的教授李仁政，问他为什么要带学生来景德镇创作作品？他说，他年轻时曾在日本留学，认为日本陶艺的技艺和釉料最丰富，后来到了景德镇才知道，景德镇的技艺和釉料是全世界最丰富的地方。所以，他认为，如果问任何一个国家的陶艺家，他们最想去的地方是哪里？90%的人都会说是"景德镇"，景德镇已成为世界陶艺家的"圣地"。

十、年轻人们的梦想之地

随着社会的发展，景德镇当地工匠的成分正在迅速的发生变化，一部分仍然是来自于传统，另一部分则是来自于全国各个艺术院校的毕业生。他们来到景德镇，在这里安家建立自己的工作室，在这里他们找到了自己的定位和要发展的方向，乐天陶社每个星期五晚上都有来自不同国家的著名陶艺家做讲座，在三宝陶艺村聚集着不同国家的陶艺家们在那里做陶艺，景德镇市政府每年举办一次的陶瓷博览会和国际陶艺展等，让他们即使在景德镇也有了国际性的视野和国际的文化氛围。同时景德镇的历史和传统，景德镇的瓷土和技艺给了他们许多的营养，最重要的是他们的作品在中国新的经济和新的城市生活中具有广阔的市场，他们为艺术而做陶瓷，也为新的生活方式及新的城市建设而做陶瓷，因此，他们是景德镇最有希望的新生代。（插图七，每个星期六年轻的大学生和在景德镇建立工作室的年轻陶艺家们，都在乐天陶社的院子里举行自己作品的展销会。方李莉摄〔参见英文插图〕）

就像北京"798"艺术区已成为众多当代中国思想新锐、个性鲜明的艺术家的聚集地，古老瓷都景德镇也为云集于此的海内外陶瓷艺术家提供了一个"孵化"灵感与梦想的空间"，而这种灵感与梦想的空间是由外来艺术家和当地的工匠们共同创造的。这种现象在历史上从未发生过，因为这是一种新的文化现象，这是全球化时代文化和艺术重构的一个部分。

注解

1、景德镇市志编纂委员会编《景德镇市志略》，汉语词典出版社1989年版，7页。
2、明王世懋《二酉委谭》，《纪录汇编》版。
3、清乾隆四十八年《浮梁县志》卷一。
4、《浮梁县志》卷十二，杂记。
5、彭雨新等主编《中国封建社会经济史》，武汉大学出版社1994年版，410页。

PORCELAIN:
A CONTEMPORARY CULTURAL TOUCHSTONE

Nancy Selvage

A WESTERN PERSPECTIVE

Thanks to abundant raw materials provided by southern China's unique geological history, centuries of clay and glaze development, large scale imperial patronage, ravenous global demand, and an enormous industry of specialized and skilled clay fabricators, glaze painters, and kiln firers, Jingdezhen in Jiangxi province has a thousand-year history of porcelain production. It was the major source of porcelain for the imperial court as well as for the entire world from the thirteenth through the early nineteenth century (see map, p. xxii).

CERAMICS: SCIENCE AND ART

Ceramics is an empirical science as well as an art form developed from experience and observation. In addition to the impact of diverse cultural values and social needs on the art, the wide range of chemical variation in its raw materials is integral to the diversity of ceramic practices throughout the world. The degree of feldspar decomposition in clay deposits and the degree of mixing with other minerals produce many, many different clay recipes with a variety of color, shrinkage, plasticity, and firing characteristics.

In the Middle East, Europe, and the Americas the most common clays, because of their iron and flux content, are neither white nor high firing. These earthenware clays can be fired up to 1000°C (1800°F). Beyond that, they start to slump and melt.

Stoneware and porcelain clays can be fired at 1300°C (2300°F) and beyond because they have a high refractory alumina content and a lower content of fluxes (such as sodium, potassium, calcium, and magnesium). The alumina and silica from the clay gradually transform chemically and physically from flat hexagonal kaolin crystals into long interlocking mullite crystals that are fused together by fluxes into a strong, dense, stone-like matrix. Just the right mixture of white kaolin, feldspar, and silica is needed to create a pure white and dense, vitreous porcelain when fired between 1200° and 1400°C, and white clay deposits are not common. Porcelain production, then, necessitated the ability to find and prepare the suitable raw materials; specific skills for vessel fabrication, surface decorating, kiln building, and firing; and a market and/or patronage. It did and still does require a multi-generational knowledge base, testing research, and collaborative effort.

CHINA'S UNIQUE PORCELAIN

Unique geological formations contributed to the early and sophisticated development of China's ceramic technology. In the north, alluvial deposits of refractory clays were found in close proximity to veins of coal that were used as fuel for the kilns. As early as the Shang dynasty, three thousand years ago, China had kilns and clays that could be fired to the stoneware and porcelain temperatures of 1200°C.

The first Chinese true porcelains were made in the eighth century during the Tang dynasty in northern China from veins of secondary kaolin clay (i.e., transported from elsewhere by water or wind)

that may have been naturally mixed with fluxing feldspars and ash. Southern China, however, became the global center of porcelain production after its first development there in the tenth century. This area contained enormous primary porcelain clay deposits from unique geological processes. Fine volcanic ash deposits created rocks that decomposed gradually over millions of years by steam from deep within the earth. Such deposits were deeper than the alluvial deposits created by surface weathering in northern China and the rest of the world.

This unusually abundant source of raw material—that is, china stone—was already in the right composition for porcelain production. It contains kaolin, mica, feldspar, and silica. Jingdezhen's potters developed unique mining, grinding, sieving, forming, and firing techniques. This technology formed the basis for the area's "beginnings" as an imperial kiln site in 1004. Fast firings and relatively small shapes were necessary with hundred-percent china stone porcelain, which because of its high glass phase content was prone to slumping. Centuries later, the potters mined deposits with a higher kaolin content and used this material as an additive to increase the plasticity and refractory alumina content of their clays, allowing the construction and firing of larger pieces.

CHINA TRADE, CULTURAL EXCHANGE

At first, porcelain was a mysterious new material to the Middle East and Europe, where many theories developed to explain its unique qualities: Perhaps it was a resin or an ordinary pot that had been buried for a long time. Marco Polo, the Italian explorer who traveled through China in 1271 and 1295, referred to Jingdezhen as "where they make the most beautiful cups in the world; they are of porcelain and are manufactured in no other part of the earth besides that city." [1] He was so impressed with this material's durability and sheen, that he gave it the Italian name for the hard lustrous cowrie shell, *porcellana*.

Porcelain would have an enormous global impact on cultural exchange, aesthetics, ceramic technology, and daily life. Export of Chinese ceramics by sea throughout East Asia and the Middle East rapidly expanded from 750 to 950. By 1050 Jingdezhen had become important as a porcelain manufacturing center, producing white vessels with a pale bluish-green translucent glaze (*qingbai* ware). Demand for this ware and the Song dynasty's aggressive trading activities spurred an expansion of porcelain exports via Chinese vessels.

Trade with the Middle East also provided Jingdezhen with a reliable supply of cobalt for blue painting (*qinghua*) on porcelain. This mineral, which was used in Islamic ceramics and traded to China from Kashan in Persia perhaps as early as two thousand years ago, had a big influence on Chinese ceramics. Although the early Ming elite disparaged the foreign influence evident in blue-and-white wares as "likely to induce vulgarity," others were enthralled.[2] By the end of the 1300s, blue-and-white ware from Jingdezhen surpassed celadon ware from Longquan in Zhejiang as the most numerous ceramics export.

Jingdezhen became the major source of porcelain for the Chinese imperial court and for the entire world from the thirteenth through the early nineteenth century. Its potters created new forms to serve foreign tastes and dining styles. Muslim customers required large serving platters, favored floral and geometric decoration, and revered the color blue. Ottoman rulers passionately collected Chinese porcelain over a 600-year period; the Topkapi Palace in Istanbul has one of the best collections in the world with ten thousand pieces of porcelain.

Portuguese and Spanish vessels dominated the China trade during the sixteenth century. Vasco de Gama had returned from India in 1499 with Chinese porcelain as gifts for the Portuguese king, Manuel I. Sixty-four years of trade later, while dining with Pope Pius IV, Brother Barolomeu dos Mártires remarked,

"We have—in Portugal—a sort of service that, being of clay, is so much better than silver in beauty and cleanliness that I advise all princes (if a humble friar can give such advice) not to use any other service and to banish silver from their tables. In Portugal we call it porcelain, it comes from India and is made in China and the clay is so fine and transparent that the white porcelain is clearer than crystal and alabaster, and those that are striped in blue enrapture the eyes appearing like a composition in alabaster and sapphires."[3]

Initially, Chinese porcelain was almost as valuable as gold and only accessible to royalty and nobility; the elaborate European mountings made for the imported vessels are testament to porcelain's extreme value and adaptability to life in the court (see fig. 1). Later, the growing bourgeoisie was prosperous enough to afford and commission this status symbol. The Dutch East India Company became the major European trader with China of the 1600s, importing 16 million pieces of porcelain during that century, and England followed by importing 25 to 30 million pieces within a hundred-year period starting in the early 1700s. American clipper ships joined the lucrative China trade in the late 1700s.

Porcelain was prominently displayed in palaces and wealthy homes, occupying places of honor in custom-built architectural settings and appearing as symbols of prestige in family portraits and still-life paintings. The asymmetry, naturalism, and unusual conventions for depicting space in Chinese porcelain painting was refreshing and

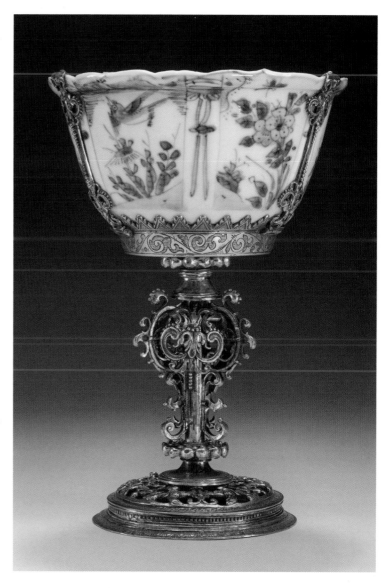

Fig. 1. Jingdezhen Kraak ware Kraaikoppen, or "crowcup," ca. 1610. Silver-gilt mounts with mark of Peter Wilber (d. 1641); porcelain, Ming dynasty, Wanli reign (1573-1620). H. 6³/₄ in. (17 cm). Peabody Essex Museum, Salem, Massachusetts, Anonymous gift, 2001, AE85461

appealing to the West. In addition, Europeans and Americans commissioned works with Western scenes and iconography. Drawings, prints, and wooden models were used by Jingdezhen artisans as templates for the commissioned exports. Mysterious calligraphy, strange iconography, bizarre costumes, foreign flora and fauna, and battle scenes from distant seas were copied and brushed onto forms that would become lidded tankards, courtly tureens with baroque appendages, and tea cups with handles in the West.

The West wanted tea, silk, and porcelains from China, and in exchange, China was primarily interested in silver and gold. Foreigners soon introduced opium smoking to China, which would tolerate a growing opium trade in the late 1700s and early 1800s until an epidemic of addiction led to a campaign against the drug traffic and then war. It is sobering to realize that some of the extensive collections of China trade ceramics now in New York and Boston area museums were acquired through the profits of such trafficking.

TECHNOLOGY TRANSFER

Europe was not able to produce porcelain until 1709, a thousand years later than China and after centuries of experiments throughout the Middle East and Europe. These experiments failed to produce porcelain, but did develop valuable and unique new ceramic technologies.

A major breakthrough was made in Iraq in 900: a tin-opacified lead glaze was developed to provide a lustrous white surface, which hid the tan clay body and provided a stable background for painting colored glazes at lower than porcelain temperatures. This technology soon spread across the Islamic world and into Europe.

In addition, Middle Eastern potters developed dense white clay slips to provide a white background for brilliantly colored glaze painting. Building upon their four-thousand-year history with glass and faience, they had also developed dense white clay bodies to imitate porcelain at lower firing temperatures. Centuries later, Italian potters developed a similar imitative body—a type of soft-paste porcelain.

For ceramic artists of the Middle East and Europe, the necessity of working at lower temperatures had the advantage of a wider range of color options for surface decoration. Many of their mineral colorants would have burned out or melted at porcelain firing temperatures. In China, foreign products inspired the development of multi-colored glaze painting on fired porcelain, which would be re-fired to a lower temperature.

In Europe, there was a lack of experience with high temperature firing except in Germany. Crucibles and stonewares were made there as early as the 1400s. Augustus the Strong, who ruled German Saxony and Poland from the late 1600s to early 1700s, was a manic collector of Chinese and Japanese porcelain. He imprisoned an alchemist, who had failed to turn mercury into gold, and ordered him to find the secret of porcelain. The alchemist, Johann Friedrich Böttger, guided by the physicist Ehrenfried Walther von Tschirnhaus, discovered the high firing temperature and the combination of white clay, feldspar, and silica required to create a hard-paste porcelain. This technological success and the patronage of Augustus supported the establishment in 1715 of Meissen, the first European porcelain factory, near Dresden. This porcelain technology soon led to the creation of other porcelain industries in France and England.

These industries created hard-paste and soft-paste porcelain to imitate Chinese wares. An English plate, popularly known as "the golfer and caddy" (fig. 2), is an interesting example of the misinterpreted iconography and use of Chinese decorative motifs characteristic of

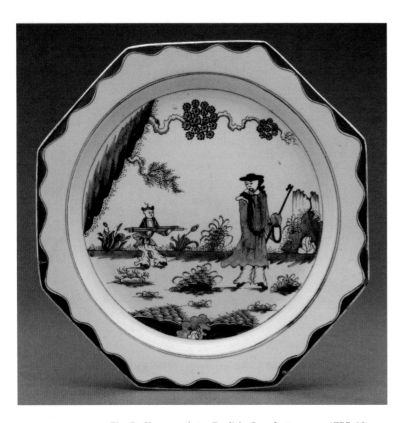

Fig. 2. Charger plate. English, Bow factory, ca. 1755-60. Soft-paste porcelain with underglaze-blue decoration. H. 1¼ in. (3.18 cm), diam. 33 cm (13 in.). Seattle Art Museum, Gift of Garry L. White in memory of Walter H. Meyer, 92.167

Chinoiserie, an eighteenth-century European style influenced by Chinese aesthetics. "In the genre of Chinese scenes that inspired this popular Bow [an English factory] pattern, the base of the precipitous rocky cliff under which the figures pass would have been anchored at the ground line in the lower scene, with trees growing out and upright, or hanging straight down the cliff face because of their weight, in a more natural fashion. . . . At Bow, this portion of the motif is segregated, as if disconnected, and painted along the side of the plate."[4]

Except for European craftsmen invited by the Kangxi emperor in the early 1700s to teach enamel glazing techniques to Chinese porcelain decorators, the China trade's cultural exchange did not involve travel by artists or craftsmen.

A CONTEMPORARY CULTURAL TOUCHSTONE
Jingdezhen: Porcelain Mecca for Contemporary Artists

From the nineteenth to the mid-twentieth century Jingdezhen came to lose its prominence while England's industrial revolution, coal, white clay, and good transportation system made Stoke-on-Trent the center of porcelain production for the world. Britain annually produced millions of ceramic products for its aristocracy, growing middle class, and vast colonial (and post-colonial) empire. But still, Chinese influence survived and spread in the decorative motifs applied to British tableware.

Within the past generation, European industrial manufacture of ceramics has been in rapid decline or entirely eliminated by global competition from cheaper production in Asia. Jingdezhen is experiencing a renaissance and has a new role to play in the development of world ceramics. Now that artists, craftsmen, and designers in China and the rest of the world are much more mobile, this city has become a mecca for Chinese and international talent.

Since the late 1990s, major economic shifts—China's reform policies, the closing of state factories, the resulting layoff of 90,000 Jingdezhen ceramic workers,[5] and the growing national and global markets for Chinese porcelain—have enabled private workshops to re-emerge in Jingdezhen. The gradual revival of these workshops has instilled this center with a new entrepreneurial vitality. In this city of 1.5 million residents, more than one hundred thousand are engaged in a porcelain production that spills out from small family workshops onto the sidewalks and streets. Enormous handmade porcelain tiles (the largest produced by man or machine anywhere in the world) are drying in the open along the side of a back street. Large vessels on their way to and from kilns and shops are transported through back alleys and main streets in wheelbarrows and open-bed pick-up trucks. Jingdezhen's rich history is alive in a contemporary practice so skilled that connoisseurs have difficulty distinguishing ancient antiques from some current reproductions.

This remarkable concentration of ceramics expertise and creativity has attracted large numbers of students, artists, and designers from within and beyond China. A thousand years of multicultural assimilation provide a smorgasbord of porcelain possibilities for visual artists from diverse, mobile, and eclectic societies. They desire to learn about Jingdezhen's unique porcelain technology, to immerse themselves in its vital cultural legacy, and to access its amazing production resources. A variety of educational programs, artist residencies, and museums, as well as a wealth of skilled labor and studio workshops, support the increasing influx. In exchange, national and international artists and designers bring new ideas and commissions that expand visions and options.

ART EDUCATION IN CHINA SINCE THE CULTURAL REVOLUTION

Since the end of the Cultural Revolution, Chinese artists have had growing opportunities for study, travel, and emigration. Many, who grew up during the disruptive turmoil of that era, have rapidly made up for lost time. During the past thirty years, they encountered and assimilated formal aesthetics, expressive options, and conceptual attitudes that had been pioneered, developed, and explored primarily in the West throughout the twentieth century. Since Eastern philosophy and aesthetics have already had a significant influence on some twentieth-century art, especially in ceramics, the expanded exposure to Western visual culture was not a totally foreign encounter.

During this rapid reconstruction period many Chinese artists have recovered personal and national pride (and received international acclaim) by focusing on the resurrection and contemporary evolution of their own rich cultural traditions. Porcelain artists have been in the unique position of being able to participate in the resurrection, preservation, and development of their cultural heritage in Jingdezhen, where craft skills, passed down through a millennium of porcelain production, were still alive at the end of the Cultural Revolution.

In 2011, Lian Duan, educator, writer, and translator, wrote an article in conjunction with his interview with Dr. Wang Chunchen, renowned art critic and Head of the Department of Curatorial Research of the Central Academy of Fine Arts Art Museum in Beijing. Duan's observation of Wang's strong historical sense provides a relevant framework for considering the development of contemporary Chinese porcelain art:[6]

> Without . . . an historical sense, it would have been difficult to imagine how Western formalism could have been so influential in China in the 1980s. After all, this was when postmodernism replaced formalism, and formalism had already lost its theoretical ground and academic priority in the West. In the 1980s, Western formalist theory was needed by Chinese artists and art educators, and was used as a workable and effective weapon in fighting against the politicized art and art education that was influenced by Soviet ideology which had dominated the Chinese education system from the late 1940s through the 1980s.

He also noted that "in the 1990s, Westernization in Chinese education in visual art was deepened while the value of Chinese cultural tradition, such as Confucianism, was also recognized."[7]

During the past decade, a new generation of Chinese artists absorbed the educational philosophy that Lu Pinchang, Vice Dean of the Sculpture Department at the Central Academy of Fine Arts, expressed at a 2009 conference in Jingdezhen: "Follow the teaching guideline of making the past serve the present and foreign things serve China, and accept all the outstanding foreign and Chinese cultural and technological resources from the past and present with an open attitude."[8]

Mining foreign cultures has been a practice in the West throughout the twentieth century; however, the resources have been processed for self-expression rather than national service. Since contemporary Chinese and Western artists are now mining the same resources, distinguishing differences of expressive intent is complex. A wide range of interpretations can be applied to works that share visual similarities.

ARTISTS IN THE EXHIBITION

All of the contemporary artists in this exhibition are an integral part of the global art community. Like their global colleagues, they are exploring a wide range of expressive possibilities from a variety of cultural perspectives, generational experiences, and personal sensibilities. Each brings unique and shared sets of motivations, values, and skills to their creative work in porcelain.

China's Post Cultural-Revolution Ceramic Artists

Lu Bin

Lu Bin's development as a sculptor reflects the thirty-year evolution in Chinese art and art education described above. Sun Zhenhua of the Shenzhen Sculpture Academy writes the following on Lu's art:[9]

> [He] graduated from the Ceramics Department of Nanjing College of Art in 1988. Like most young artists in the 80s, he was also influenced greatly by western modern formalism. . . . The focus then was on rebelling against the confinement of traditional ceramics forms and its consequent categorization [as] a branch of industrial art. . . .
>
> From the mid-90s, when Lu Bin chose an artistic direction towards a more contemporary expression, it was the old and entrenched ways of a decades old modernism, rather than tradition, that challenged him.
>
> . . . If modernism changes ceramics into art, as we say, contemporary ceramics hopes to change from the art of beauty into a cultural art form. Acquiring its pure aesthetic taste, the ceramics of modernism gave up its inherent relation with life. . . .
>
> . . . [Lu Bin's *Urban* series and *Type* series] take on the spirit of daily life through the realization of common themes.
>
> . . . and [they] express the awakening of a strong Chinese cultural sense.

During the past decade, in his *Fossil* series (cat. no. 29), Lu Bin has synthesized and expressed his feelings about the past, present, and future by concentrating on the fundamental nature of ceramics as a medium of preservation. Instead of rejecting traditional ceramics, Lu Bin's mature and "post modern" perspective now enables him to consider the past as a conceptual element within a broader context. He writes: [10]

> Ceramics, having many similarities to stone and fossil, . . . has provided a detailed [impression] of the times for scholars later. . . . Each great change in the style of ceramics is closely related to great changes of history and culture, thus reflecting what Zhu Yan, a famous scholar of [the] Qing Dynasty, said "Knowledge of politics is based on changes in the history of ceramics." . . .
>
> . . . Those art works which are brave in recording contemporary puzzles and pains will eventually have opportunities of being placed into glass cabinets in future museums. Because [they depict] the features of this age, [they will] become the "fossils" of today's life.

Caroline Yi Cheng

As Lu Bin acknowledges, recording contemporary "puzzles and pains" during times of social change is a challenge. Many Chinese artists have tested and exceeded the limits of expressive freedom tolerated by state officials. Caroline Yi Cheng's earlier ceramic sculptures were occasionally censored from exhibitions. She has infused in those sculptures irreverent political puns, wacky humor, and exuberant

self-confidence evolved from formative experiences and education in Hong Kong, Europe, and the United States. Her current work offers a more nuanced commentary on Chinese society. In her words,[11]

> China has many complex personalities, many different cultures mixed into one large pot.
>
> . . . Auspicious symbols are placed in homes to bring good luck and happiness. They use symbols such as bats, deer and peaches because these words sound like fortune, prosperity and longevity.
>
> I have called my butterfly outfits *Prosperity* also because "Clothing 服" and "Prosperity 福" are pronounced the same way "fu". These outfits from afar look just like a dress, but when you look closely at the butterflies they are all unique and different. This is China!"

By commissioning the fabrication of thousands of small porcelain butterflies for these dress sculptures (e.g., cat. no. 25), Cheng features the talent of Jingdezhen's skilled artisans and provides them with new work opportunities and experiences.

Her porcelain-laden garments are both reminiscent of and in sharp contrast to Han dynasty jade burial suits. Both share a labor intensity and precious material weight that elevate them far beyond the realm of fashion into the categories of ceremony and symbolic performance. Jade suits were made to ensure the immortality of the male-dominated aristocracy. Butterfly dresses celebrate a vibrant feminine presence with symbols of transformation: enduring representations of an ephemeral existence.

Cheng has done the most as an individual (without institutional or government support) for contemporary ceramics in the world. Since assuming the directorship of Hong Kong's Pottery Workshop in 1997, she has rapidly expanded this educational program by establishing new facilities in Shanghai, Jingdezhen, and Beijing. During the past decade she has focused on developing the Shanghai and Jingdezhen programs by building excellent studio facilities and offering classes, residencies, exhibitions, and lectures that serve the local communities and attract hundreds of international artists and students. She has also provided a direction and an outlet for young ceramic artists in Jingdezhen by establishing and curating the very successful Sunday markets. Her amusing and provocative blogs on Renren and Weibo are extremely popular with a large following of Chinese ceramic students and young professionals. Beyond China she maintains a lively international dialogue on Facebook.

Yao Yongkang

Yao Yongkang's development as a figurative sculptor reflects the progression of contemporary art in China from social realism, through modernism, to a renewed interest in Chinese cultural traditions. Since 1997 Yao Yongkang's porcelain work has embodied his yearning for the birth of a new human spirit for the new millennium. In his *Millennium Baby* series (cat. no. 21), a singular child with remarkable self-awareness is usually seated on the back of a dog or fish (Chinese symbols of loyalty and good fortune), sheltered by a lotus leaf (a Buddhist symbol of purity), and entwined with a lotus stem (symbol of Buddhist teachings that elevate the mind from worldly concerns). The child's central location, frontal stance, alert posture, and slightly open mouth engage our attention and expectations.

Spiritual enlightenment is associated with the innocence of a child through Yao Yongkang's use of Buddhist iconography and his approach to handling clay and glaze. The baby's extended fingers are expressive of Yao Yongkang's tactile connection with porcelain. He values the process of touch so highly that he sometimes makes sculpture with his eyes closed, believing that human nature is best expressed through haptic communication. The lotus leaf is a soft porcelain slab: the unifying element used by Yao

Yongkang to model his figures with child-like simplicity and directness. All is one—undulating in the fluid celadon glaze and connected by the umbilical lotus stem.

The choice of celadon brings traditional cultural values to Yao Yongkang's new millennium babies. At the beginning of the last millennium, Song dynasty ceramicists mastered centuries of evolving celadon technology to capture the subtle colors and qualities of jade in their glazes. Jade (and by extension celadon) was endowed with supreme moral, spiritual, and protective powers.

Yao Yongkang and Zhu Legeng are the only contemporary artists in this exhibition who have been based in Jingdezhen throughout their student and professional lives, and Zhu Legeng is the only one who was born in Jingdezhen.

ZHU LEGENG

In contrast to previous generations of porcelain vessel makers who specialized in only one part of the fabrication process, Zhu Legeng wanted to be involved with the whole process: forming, surface glazing, and firing. With this Western studio-potter approach and the expanded horizons available to Chinese artists of his generation, Zhu Legeng used his extensive training with Jingdezhen's porcelain clay and master glaze painters to embrace a wide range of expressive strategies and create murals, sculpture, vessels, and tiles.

Zhu Legeng's masterful glaze-painted vessels evolved from his unique combination of Chinese porcelain painting techniques on Japanese folk pottery forms. His murals combine a modernist focus on abstraction with a celebration of porcelain's unique physical character. The wide-open space and solitary horse in his *Heavenly Horse* sculpture (cat. no. 24) evoke a sense of wild freedom—a freedom that is drenched and wading in a deep pool of traditional *yingqing* glaze. Zhu's *Lotus Figures* series, including *Zen* (cat. no. 22), embody the inner strength and restraint of the spiritual practice of Buddhism. In contrast, he emphasizes the drive to communicate with an external god in the wide, uplifted mouths of his *Hymn Singing* Christian figures.[12]

"Recalling my own 30-years of ceramics creation," Zhu writes, "I may say that it's a miniature of Chinese ceramic art changing from tradition to modernity and from enclosing to opening." And on the challenges of his early career, he continues, "At the beginning of the reform, the planned economy left no chance for a ceramic artist to have an individual studio or kiln. All designs and creations were only paper designs, which were realized by factories. The most [common] practice was to buy a plain vessel and paint on it."[13] Now Zhu Legeng is working in his large private studio with several kilns.

For Yao Yongkang, Zhu Legeng, and other artists in Jingdezhen, porcelain is a given. For those working elsewhere in China or abroad, porcelain is a choice.

CHINESE DIASPORA ARTISTS AT JINGDEZHEN

Many contemporary Chinese diaspora artists use porcelain as a "touchstone" for expressing and examining cultural identity. They have therefore been attracted to Jingdezhen.

AH XIAN

Ah Xian received political asylum in Australia, now his homeland, soon after the violence in Tiananmen Square. His *China, China* series (cat. nos. 44–47), created in Jingdezhen a decade later (from 1999 to 2004), expresses the complexity of his relationship with his motherland. Ah Xian juxtaposes Western bust forms, portraying himself and others, with rich surfaces of painted and

modeled Chinese decorative imagery. Despite the traditional rendition of familiar designs and benevolent symbols, the bold interaction of this glazed imagery with the passive white body often evokes disturbing emotional overtones.

He is a pioneering example of the growing number of contemporary artists who come to Jingdezhen to make unique works with the skilled technical support of Jingdezhen's traditional artisans. Of his relationship with traditional workshops, Ah Xian writes: [14]

> The way that I have been working with materials is trying to bring the ancient works, traditional materials and craft skills into a contemporary art field where traditions and craftsmanship are often not necessarily cared [for] and valued much. . . .
>
> . . . When I walk into a workshop to see what they [traditional artisans] do, . . . [I] introduce my ideas to them. . . . The initial response of the crafts people was usually laughter, and they asked, what was that idea useful for?
>
> . . . Gradually there have been an increasing number of contemporary artists who are entering into a range of traditional craftsmanship fields and areas, and approaching workshop owners. As the owners see the outcomes, they are changing their minds about the relevance of contemporary art.

Ah Xian's *China, China* series has had a major impact in China and in the West. "In 2000 shortly after completing [a series of] porcelain pieces in Jingdezhen," he writes, "I transferred them back to Beijing and managed to have a show at the Art Gallery of Beijing Formal University. The response was overwhelming, mostly from young people. . . . They felt excited to see the new idea and a new appearance of porcelain. What they knew about porcelain before was almost all the traditional appearance of functional ware and some idealized Buddha statues plus Mao's portraitures from the Cultural Revolution period."[15]

Holland Cotter's perceptive review of Ah Xian's work in *China Refigured*, Asia Society's 2002 New York exhibition, poses important and relevant questions for us to reflect upon as we confront contemporary Chinese porcelain. He writes, "In every case, the potent cultural symbols of an earlier China appear like birthmarks—at once an ornament and a blemish—on contemporary faces from China and the Chinese diaspora in the West, evoking questions. What does 'Chinese' mean in a global context? Is it intrinsic or cosmetic, something you inescapably are or something you choose to be? Is appropriation of art of the past a way to connect to that past, or to gain distance from it? Does it create a new Orientalism, giving the West the Asia it thinks it knows and wants? Or is it a signal that an increasingly insular contemporary Western art is having less and less relevance for artists with strong formative roots elsewhere?"[16]

SIN-YING HO

Now that contemporary artists are as mobile and multicultural as Jingdezhen's historic exports, China-trade porcelain has a new relevance for many Asian diaspora artists. In Sin-ying Ho's *Fracture Unity* (not exhibited), *Hero* (cat. no. 26), and *Made in the Postmodern Era* (cat. no. 27) series, the juxtaposition of plastic forms and surface decoration is analogous to the cultural mix of Chinese materials with foreign styles in trade porcelain. The artist's great interest in the hybrid nature of historic export ware reflects her own multi-cultural experiences and family histories.

By combining popular culture icons or contemporary symbols and images with intact or fragmented

classical Chinese forms and traditional glaze painting, Sin-ying Ho's vessels embody her diaspora experience and the complex synthesis of contemporary global culture. She is a highly respected cultural ambassador who has introduced her creative interpretation of Jingdezhen's cultural heritage to diverse international audiences through an active teaching career, workshops, lectures, exhibitions, and numerous publications.

Currently living in New York City, Sin-ying Ho is also a pioneering example of a contemporary artist coming to Jingdezhen with a developed personal vision for her work and a goal of learning traditional techniques to enhance that vision. During sixteen years of studies, residencies, and studio work in Jingdezhen, she has mastered glaze painting and wheel throwing techniques and created several ambitious series of sculptures and vessels (see fig. 3).

ZHAO MENG

Zhao Meng, who had moved to the US in 2002, embarked on a pilgrimage to Jingdezhen in the summer of 2011 with a quite literal "touchstone" impetus. He had created ceramic scholar rocks (cat. nos. 35 & 36) with a wide range of earthenware, stoneware, and porcelain clays in his studio at the Harvard University Ceramics Program during the previous five years. From his student experience with ceramics at the China Academy of Art in Hangzhou, Zhao knew that he would need to invent new construction

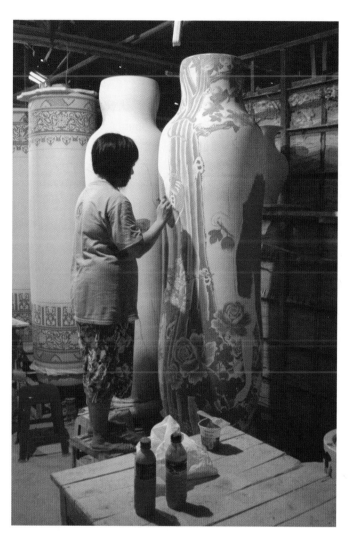

Fig. 3. Sin-ying Ho painting Temptation: Life of Goods No.1 in Jingdezhen studio, 2010

techniques in order to model the complex forms of his scholar rocks in China (cat. nos. 37–39). Porcelain clays from the USA and Europe are more plastic and easier to use for hand-building than Jingdezhen's clay because of geological, chemical, and particle-size differences. Instead of adding and modeling soft, wet clay in many stages as he did in Boston, Zhao carves into a dry, solid block in Jingdezhen.

The forms and surface treatments of his sculptures evoke a rich mix of associations. Some of his shapes are based on the forms of revered scholar rocks depicted in well-known Chinese paintings. The philosophical yin-yang interplay of ephemeral and enduring energy informs the content of his sculpture as well as his working process. Rather than imposing his style on natural "subjects," Zhao simulates geological processes to create eroding and erupting forms. His scholar rocks are evolving to subtly suggest anthropomorphic gestures.

The veneration of rocks in China has a long cultural history as well as legendary origins. To save mankind the goddess Nü Wa repaired disastrous damage to one of the pillars of the sky by finding some special five-colored soil, firing the soil in an oven to produce 36,000 rocks, infusing the rocks with her power, and using them to rebuild the broken pillar. Ancient lore claimed that all the rocks on earth were remnants of the goddess's heroic "firing" and possessed some of her power.[17] Nü Wa was as selective in her choice of raw materials as historic and contemporary porcelain makers, and she was engaged in the

same transformative process of heating soft materials to create hard rocks. Porcelain is one of the strongest, most durable rocks that man has ever made. The reverence for rocks and porcelain in Chinese culture is merged in Zhao Meng's porcelain scholar-rock sculptures.

ATTRACTION OF JINGDEZHEN FOR WESTERN ARTISTS

Why are contemporary Western artists and designers attracted to a porcelain center that creates exquisite perfection with traditional skills, forms, and imagery in a process that separates and sequences the manufacture through a set of specialized workers in a manner similar to factory production? And why are they much more interested in Jingdezhen's history and resources than they would have been a generation or two ago? There are many reasons.

Throughout the twentieth century most Western studio potters and artists rejected the decorative tastes, skilled perfection, and value of the bourgeois objects associated with Chinese export ware, and they rejected the process of industrial manufacture. The China trade had had a big influence on the romantic and florid aesthetics of eighteenth-century European Rococo porcelain. In the nineteenth century the ornate Rococo Revival style came to be mass produced in England's Industrial Revolution factories, creating a glut of Victorian excess that provoked an aesthetic and social rebellion in the Arts and Crafts Movement. This movement promoted the manufacture of simpler, handmade objects for the benefit of society in medieval-style workshops. However, many twentieth-century painters and sculptors also rejected the skill and training of traditional craftsmanship as interfering with personal expression. Several generations of potters embraced the medieval Japanese Zen appreciation of "natural" expression through accidental irregularities in form and material impurities.

In sharp contrast to these twentieth-century aesthetic values, the purity of white porcelain has regained favor among studio potters, contemporary artists are finding new relevance in eighteenth and nineteenth-century aesthetics, and there is a renewed interest in industrial products and processes. For Western artists these areas of relevance include appropriated reuse, reinterpretations of cultural iconography, provocative social commentary, nostalgia with a conceptual edge, and collaborative production processes. Surviving porcelain industries in Europe and American have invited artists to design limited-edition productions and have hosted residencies in which artists were given free rein to create their own work using the factory's technical and labor resources.

WAYNE HIGBY

Since his participation in the first conference on contemporary ceramic art, held in the Peoples' Republic of China in 1991, Wayne Higby has done more than anyone else to build bridges between contemporary Chinese and American ceramics. As a Professor of Ceramic Art at Alfred University, Higby established and facilitated formal exchange agreements between Alfred's School of Art and Design and many Chinese institutions including the Hubei Academy of Fine Arts in Wuhan, Jingdezhen Ceramic Institute, Central Academy of Fine Arts in Beijing, and Central Academy of Fine Arts's College of City Design. Through these exchanges and the personal motivation of his passionate interest in Chinese ceramics, Higby has lectured, taught, and traveled throughout China, and he has taught, mentored, and hosted Chinese students and colleagues at Alfred University. His accomplished Chinese graduate students have returned home as influential educators contributing to China's development of contemporary ceramic art. Higby's enormous contributions have been acknowledged by many honors, including being the first foreign national to become an honorary citizen of Jingdezhen.

He describes his sculptural ceramics (cat. no. 41–43) as a "meditation on the relationship of mind and matter."[18] In fact, he did not feel connected enough with porcelain to use it as his own expressive material until after many years of experiences in Jingdezhen and after time to meditate on a chunk of raw white clay that he collected from Gaoling Mountain and enshrined on an elegant polished wooden base in his New York studio. He writes, "The sensual and celestial qualities of the material have captured me. My personal interest in the meaning of landscape has been advanced and my love of China has come alive in the reality of process."[19]

Higby's porcelain sculptures and murals fuse the concrete physicality and fractured geology of raw porcelain with the illusion of a vast landscape. His sculptural interventions appear to be a natural phenomenon. In *Lake Powell Memory—October Rain* (cat. no. 43), it is difficult to distinguish his subtle low-relief drawing from natural fissure lines in the clay or crackle lines in the glaze. Intent, substance, and process merge into one. This sculpture, created by a Western artist with Western clay, is an integral part of Jingdezhen's legacy.

CODA

All of the artists in this exhibition have invigorated the development and flowering of contemporary porcelain art in Jingdezhen with the diversity and quality of their experiences, skills, ideas, and visions. The confluence of new opportunities for social exchange, travel, and creative development within a community—one that has maintained the infrastructure and skills for a millennium-old craft tradition— is an extremely rare set of circumstances. This fertile period in Jingdezhen's remarkable history is nourishing a new generation of local talent, capturing global attention, and attracting national and international artists, craftsmen, and designers.

NOTES

1. William R. Sargent, "The Significance of Exports and Trade During the Later Dynasties," in *Chinese Ceramics from the Paleolithic Period through the Qing Dynasty*, ed. Li Zhiyan, Virginia L. Bower, and He Li (New Haven and London: Yale University Press, 2010), p. 571.

2. Kanazawa Yoh, "The Export and Trade of Chinese Ceramics: an Overview of the History and Scholarship to Date," in *Chinese Ceramics from the Paleolithic Period through the Qing Dynasty*, p. 566.

3. Sargent, "The Significance of Exports and Trade During the Later Dynasties," p. 572.

4. Julie Emerson et al., *Porcelain Stories: From China to Europe* (Seattle: Seattle Art Museum in association with University of Washington Press, 2000), p. 205.

5. Maris Boyd Gillette, e-mail message to the author, June 15, 2012, and in conversation with the author, June 17, 2012.

6. Duan Lian, "Western Influences on Chinese Education in Visual Culture: A Cross-Cultural Study of Chinese Responses to Western Art Theory about the Image," *Marilyn Zurmuehlen Working Papers in Art Education*: Vol. 2011: Iss. 1, Article 1. Available at http://ir.uiowa.edu/mzwp/vol2011/iss1/1. Portions of this article was incorporated into the author's thesis "Western Influences on Contemporary Chinese Art Education: Two Case Studies of Responses from Chinese Academics and College Students to Modern Western Art Theory" (PhD thesis, Concordia University, 2012); see http://spectrum.library .concordia.ca/973749/4/Duan_PhD_S2012.pdf.

7. Ibid.

8. Lu Pinchang, "Teaching Pedagogy: Chinese/American Approaches to Ceramic Education," *Chinese/American Ceramic Art and Education* (conference lecture, Jingdezhen: National Council on Education for the Ceramic Arts / Jingdezhen Ceramic Institute International Symposium, 2008).

9. Sun Zhenhua, "Lu Bin's Recent Works and Contemporary Ceramics," accessed June 18, 2012, http://www.lubinceramic.com /en/Review.htm#no1.

10. Lu Bin, "Fossil 2000" (artist statement), http://www.lubinceramic.com/en/Review.htm#no3.

11. Caroline Yi Cheng, artist statement at *The Pottery Workshop*, accessed June 29, 2012, http://www.potteryworkshop.com.cn /nceca /gallery/?type=detail&id=28.

12. Zhu Legeng, *Collection of Ceramic Art Works of Zhu Legeng: Environment/Art/Clay* (Beijing: Culture and Art Publishing House, 2009), pp. 68–70.

13. Ibid., p. 193.

14. Ah Xian, "Ah Xian, Ancient crafts, contemporary practice—a new language of art," interview by Kathryn Wells, *Craft Australia*, 28 September 2011, http://www.craftaustralia.org.au/library/interview.php?id=ah-xian-ancient-crafts -contemporary-practice.

15. Ibid.

16. Holland Cotter, "'China Refigured'—The Art of Ah Xian with Selections from the Rockefeller Collection," exhibition review, *The New York Times*, November 08, 2002.

17. Willow Weilan Hai Chang, *Spirit Rock, Sacred Mountain: A Chinese View of Nature* (New York: JYoung Art, 2011), p. 1.

18. Wayne Higby, "Artist's Statement," *School of Art & Design @ Alfred*, accessed June 29, 2012, http://art.alfred.edu/faculty /ceramic-art/wayne-higby/.

19. Wayne Higby, "The Spirit of Porcelain," opening keynote address presented at "The Spirit of Porcelain, International Ceramic Art Conference" (Jingdezhen, May 2000).

瓷器——现代艺术的试金石
Nancy Selvage

　　江西景德镇有着一千年的制瓷史，它地处南中国，特有的地理环境为它提供了丰富的原材料，几个世纪的瓷土和釉料生产技术的发展，大规模定烧御用瓷，供不应求的全球贸易，并拥有各种具备专业熟练技能的拉坯工、釉工、烧窑工，形成了庞大的产业体系。从十三世纪至十九世纪初，这座小城不仅是御用瓷的主要烧制地，也是整个世界的瓷器生产地。它对全球范围内的文化交流、审美、制瓷技术以及日常生活都产生了巨大的影响。

　　中东与欧洲经过了几个世纪的实验，欧洲才终于在1709年生产出第一件瓷器，比中国晚了一千年。这些实验虽然没能创造出瓷器，却为发展新的陶瓷技术做出了贡献。

　　在过去的几十年中，景德镇正在重获新生，在世界陶瓷发展的舞台上扮演着新的角色。当代艺术家们正如景德镇历史上的外销瓷一样，具有流动性与多元化特征，这座城市所积累的深厚的陶瓷专业知识以及创造性使它成为中国乃至全世界学生、艺术家和设计师们心中的圣地。各种培训计划、艺术家驻地和大量的熟练工、工作室给这些"朝圣者"提供了条件。同时，这些外来者带来的想法与定制业务也拓宽了景德镇的视野与选择。

　　在改革开放时期，面对国际交流所带来的新机遇以及城市的新发展，景德镇的陶艺家致力于复兴、保护和发展文化遗产，他们将流传千年的陶瓷传统手工技艺与基础保持了下来，可以想见他们所经历的一系列情境。

　　许多中国当代艺术家被吸引到景德镇，试图用瓷作为一块"试金石"来表达与检验文化认同。对他们中的有些人来说，在中国外销瓷中将不同文化下形成的中式材料与外国样式混合起来，具有一种内在的关联性。历史上外销瓷的文化混杂性反映了个人多元文化经历和家庭谱系。

　　在二十世纪，许多西方陶艺家和艺术家拒斥装饰性、技巧的完美性以及资产阶级价值取向，从而割断与中国出口品和工业产品的关联。在与这些审美取向形成鲜明对比下，纯净的白瓷重新获得了陶艺家们的青睐。当代艺术家正在从十八、十九世纪审美趣味中探寻新的关联性，而这种兴趣也正在工业产品与工业化进程中重燃。对西方艺术家来说，这些关联范围包括了挪用、文化意象的重读、挑衅的社会性言论、概念边缘的怀旧情结以及写作生产过程。

　　此次展览中的所有艺术家以其文化视角的多样性、思想与情感的推动力、创造性与人生际遇，为景德镇当代陶瓷艺术的发展与繁荣注入了活力与生机。在景德镇非凡的制瓷史上，这一过渡时期正孕育着新一代的当地人才，吸引着全世界的目光，汇聚着中国乃至全世界的艺术家、手工艺者以及设计师。

FANG LIU [FLL] / NANCY SELVAGE [NS]

Famille-rose porcelain, known in Chinese as *fencai*, was perfected in the eighteenth century. Its palette of overglaze enamel colors is distinctive for the use of opaque pink, which was mixed with other pigments for a wider range of colors and tones than previously possible. More complex paintings could be achieved with this technique, making it very popular in the late Qing dynasty. *Famille-rose* painting remained the predominant type of decoration in the commercial workshops of Jingdezhen in the early part of the twentieth century.

The **Jiangxi Porcelain Company**, founded at the end of the Qing dynasty in 1910 with private and government funding, continued the traditional styles of the late Qing into the Republican period before ceasing operation sometime in the 1930s. Notably, the Company set up a school for ceramic research which was later taken over by the Jiangxi provincial government; it trained many of the important ceramic artists of the period. Another workshop, **Ju Ren Tang,** made porcelain for the president, Yuan Shikai, and the government for only one year (1916) during the early Republic of China.

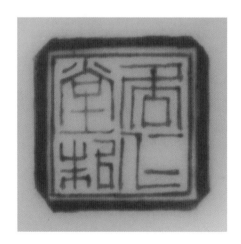

1. 居仁堂　一对瓷瓶
Ju Ren Tang (Hall of Living in Benevolence)
Pair of Vases, 1916

Four-character red seal mark: *Jurentang zhi*

Famille-rose porcelain

Height 4¾ in. (12 cm)

Collection of Chen Haibo

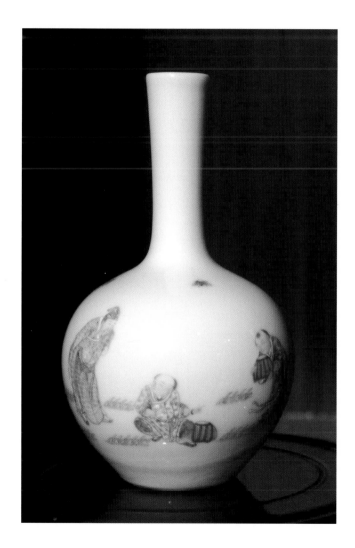 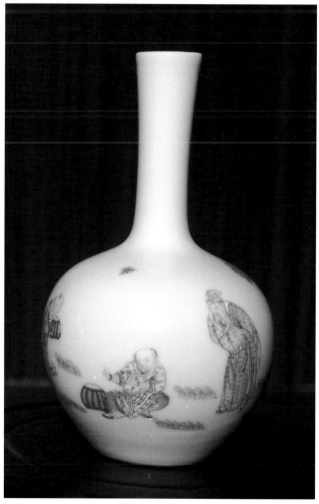

Ceramic artists working for commercial workshops like the Jiangxi Porcelain Company were influenced by the renowned Eight Friends of Mount Zhu, based in Jingdezhen. One such artist was **Liu Xiren** (1906–1967), who was born in Nanchang county, Jiangxi. He came to be recognized for his works in the 1930s. In his earlier years he painted for the Nanchang Lizexuan Ceramic Village. By the late 1940s, he had his own shop in Nanchang. Although based in Nanchang, his work is often compared to that produced at Jingdezhen. His figure painting style is very similar to that of Wang Qi (see cat. no. 3), leader of the Eight Friends. Liu also specialized in flower-and-bird paintings and snow landscapes. [FLL]

2. 刘希任　瓷瓶
Liu Xiren (1906-1967)
Vase, early 20th century

Six-character mark: *Jiangxi ciye gongsi*
Famille-rose porcelain
17 x 6 x 5 in. (43.2 x 15.2 x 12.7 cm)
Collection of Beatrice Chang

三径就荒/松菊犹存/时在甲子仲秋日/刘希任写于珠山/[朱文方印]"希任"
Inscribed: "When all the plants have withered in winter, only pine and chrysanthemum still keep green."
Dated signature follows the artist's square relief seal, "Xiren"

This vase was produced by Liu Xiren for the Jiangxi Porcelain Company, most likely before he established his own workshop. It is decorated with popular auspicious images. [FLL]

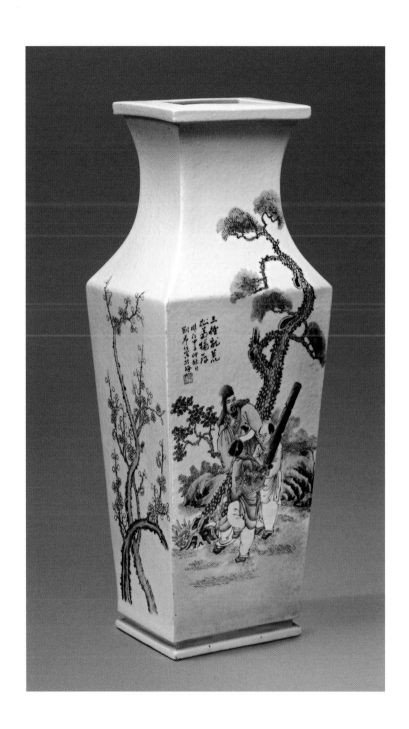

The **Eight Friends of Mount Zhu** (*Zhushan bayou*) was a group of artists (cat. nos. 3–12) based in Jingdezhen. There were in fact ten members in the group: Wang Qi, Wang Yeting, Wang Dafan, Liu Yucen, Bi Botao, Cheng Yiting, Xu Zhongnan, Tian Hexian, Deng Bishan, and He Xuren. They applied the *famille-rose* technique to ceramic painting as a way of recreating the effects and artistic approaches of Chinese painting. The works are inscribed and signed as if they were literati paintings on paper.

Born in Anhui, **Wang Qi** (1884–1937) founded the Full Moon Society (Yueyuan hui) in his early years. Members of this auspiciously named society of ceramic artists took turns hosting meetings on the fifteenth day of every lunar month for study and mutual appreciation of their works. These artists later formed the Eight Friends of Mount Zhu, the first group of ceramists in the history of Jingdezhen to exert a strong influence on the art. Wang Qi was the leader of this group. In his early years, he earned a living by making dough figurines. After 1901, he came to Jingdezhen to learn ceramic painting and portrait painting. He specialized in portrait painting using a wild cursive (*kuang cao*) stroke; he also did landscape and flower-and-bird paintings. Wang brought a breath of fresh air into Jingdezhen with his experience in sculpture making and the introduction of the Western chiaroscuro technique into his paintings on ceramics.

3. 王琦　人物图小瓷板
Wang Qi (1884-1937)
Figures, **1931**
Famille-rose porcelain panel
10¼ x 7¼ in. (26 x 18.5 cm)
Collection of Chen Haibo

画江求洛/辛未冬写西玉陶谜散人王琦/[朱文方印]"西玉","陶迷"
Inscribed with the title, *Huajiang qiu Luo* (Painting the River, Seeking *Luo* [an ancient document?]). Signature and square relief seals of the artist, "Xiyu" and "Taomi"

This plaque fully represents Wang Qi's style of painting. The clothing and surrounding scenery are executed with line and flat color in the Chinese style, but the heads and hands are described using the Western technique of chiaroscuro. Here we can see a bit of the Western influence that Jingdezhen received since the end of the Qing dynasty. [FLL]

Wang Yeting (1884–1942) was one of the Eight Friends of Mount Zhu. Born in Jiangxi, he graduated from the Jiangxi Ceramics School in 1909. He learned landscape painting from Zhang Xiaogeng and flower-and-bird painting from Pan Taoyu. Wang earned a living by ceramic painting and eventually established his own studio, Pingshan Caotang (Mount Ping Thatched Cottage). Later, he was employed as a teacher by the Jingdezhen Ceramics Vocational School. He held solo exhibitions in Shanghai and Nanchang and attended activities of the Art Research Society and Full Moon Society, which were founded by Wu Aisheng and Wang Qi. Using oil and gouache pigments, Wang Yeting created a distinctive ceramic painting style deeply affected by Zen Buddhism and the eighteenth-century artist Shi Tao. At the same time, Wang applied Chinese painting elements like poetry, calligraphy, and seals to the new *famille-rose* landscapes and made his scenes more lively and natural.

4. 汪野亭　流水鸣琴图小瓷板
Wang Yeting (1884-1942)
Playing the Qin along the Creek
Famille-rose porcelain panel
10 ¼ x 7 ¼ in. (26 x 18.5 cm)
Collection of Chen Haibo

流水鸣琴/汪野亭/[朱文方印]"野亭"
Inscribed with the title, *Liushui mingqin*.
Signature and artist's square relief seal, "Yeting"

This painting alludes to the classic theme of "High Mountain and Flowing Creek," an ancient melody for the *qin* zither attributed to the legendary scholar Bo Ya. Only his friend Zhong Ziqi could listen and understand his music. Thus, a scholar depicted strumming his *qin* by a flowing stream among tall mountains is seeking to meet his intimate soulmate. [FLL]

Wang Dafan (1888–1961), one of the Eight Friends of Mount Zhu, was born in Poyang county, Jiangxi. His ancestral home was in Shanxi, but the chaos of war caused his father's business to fail after the family had moved to Anhui. In 1901, Dafan came with his parents to Jingdezhen, where he learned ceramic painting in his elder sister's decoration workshop (*hong dian*). The famous ceramic painter Wang Xiaotang, who was employed at the shop, became mentor to the young Dafan, teaching him not only painting but also poetry. In 1915, Wang Dafan's work was among those recommended by the Jiangxi Porcelain Company and the Jingdezhen Chamber of Commerce to be included in the Panama-Pacific International Exposition, held in San Francisco; one of his *famille-rose*-decorated porcelain paintings won a gold medal.

5. 王大凡　贵妃出浴图小瓷板
Wang Dafan (1888-1961)
Guifei after a Bath, 1940
Famille-rose porcelain panel
10 ¼ x 7 ¼ in. (26 x 18.5 cm)
Collection of Chen Haibo

贵妃出浴图/庚辰仲夏月之上瀚/黟山樵子大凡王堃画/[朱文方印]"大凡"
Inscribed with the title, *Guifei chuyu tu*.
Date, signature, and artist's square relief seal, "Dafan"

The Tang dynasty imperial concubine Yang Guifei is depicted as soft, delicate, and seductive just as she emerges from the bath. This moment, when Emperor Xuanzong first sees her, is celebrated in Tang poetry as the beginning of a tragic romance that eventually plunged the country into conflict. The scene of the bath was a popular painting subject of the early twentieth century. [FLL]

4 | 5

Liu Yucen (1904–1969), whose ancestral home was Taiping in Anhui, was born in Poyang county, Jiangxi, and became one of the Eight Friends of Mount Zhu. In his youth, he was influenced by the paintings he saw in a mounting shop and started to learn painting from the well-known Poyang painter Pan Taoyu. He graduated from Jiangxi Ceramics School in 1923 and taught Chinese painting and ceramic art in the Fuliang Prefectural Ceramics School, the Mount Zhu Porcelain Art Academy, and the Oriental Art Academy successively. In 1954, he worked in the Jingdezhen Ceramics Research Center as deputy director of the Art Department and attended the first National Arts-and-Crafts Artists Congress, held in Beijing. Liu specialized in *famille-rose* flower-and-bird painting. He was influenced in his youth by the painting style of the famous Qing artist Hua Yan, but in his middle age he formed his own fresh and elegant style by drawing from the essence of Ren Bonian's and Hua Yan's painting.

6. 刘雨岑　暖春图小瓷板
Liu Yucen (1904-1969)
Warm Spring, 1944
Famille-rose porcelain panel
10¼ x 7¼ in. (26 x 18.5 cm)
Collection of Chen Haibo

暖春图/甲申新春/澹湖注刘雨岑写于/珠山麓觉厂之西楼/[白文方印]"竹"/楚翘吾兄雅玩/赖子湘敬赠/
[白文方印]"子"/[朱文方印]"湘"
Inscribed with the title, *Nuan chun tu,* followed by the date, artist's signature, and a square intaglio seal, "zhu." Two-line inscription indicating that this was a gift from Lai Zixiang to his friend Chuqiao, followed by a square intaglio seal, "zi," and a square relief seal, "xiang"

In this painting, which is alive with suggestions of early spring, a bird sits on a branch looking down on a nest of her recently hatched offspring. It is a beautiful and tender scene. The coloring is simple and elegant, its luster gentle and soft. The plaque amply displays the expressive power and the rich and meticulously layered colors which characterize *famille-rose* overglaze painting. [FLL]

Bi Botao (1885–1961), a late Qing dynasty scholar and one of the Eight Friends of Mount Zhu, was born in She county, Anhui, but came to reside in Poyang county, Jiangxi. In his early years he studied with the Poyang painter Zhang Yunshan. Bi became involved with the Full Moon Society after being introduced to Wang Qi and Wang Dafan. Famous for his seal engravings, poetry, calligraphy, and painting on paper, Bi turned to decorating porcelain, specializing in painting birds, especially such subjects as the mynah bird, mandarin duck, and paradise flycatcher. Soon after the establishment of New China, Bi joined the first staff of the Jiangxi Culture and History Museum (Jiangxi sheng wenshi guan). From then on he stopped porcelain painting and turned to writing and collating the historical materials of the Qing dynasty. Until his death in 1961, he would only occasionally paint on paper for the Museum.

Cheng Yiting (1895–1948), one of the Eight Friends of Mount Zhu, was born in Leping county, Jiangxi. He entered the Department of Painting in the Jiangxi Ceramics School in 1911, where he learned landscape and flower-and-bird painting from celebrated masters Zhang Xiaogeng and Pan Taoyu. After graduating in 1914, Cheng painted in Pufangju, a porcelain shop in Jiujiang. Soon after, he went to Shanghai and learned flower-and-bird painting from Cheng Yaosheng. He opened a shop in Jingdezhen in the 1920s and concentrated his efforts in flower-and-bird painting, eventually developing his own artistic characteristics. His works typically integrate poetry, calligraphy, painting, and seal art on ceramics. In the mid 1930s Cheng taught at the Fuliang Prefectural Ceramics Vocational School. But because of the ongoing warfare at the time, he returned to his hometown around 1940 and made his living there by selling paintings until the end of his life.

7. 毕伯涛　延年益寿图小瓷板
Bi Botao (1885-1961)
Living a Longer Life

Famille-rose porcelain panel
10¼ x 7¼ in. (26 x 18.5 cm)
Collection of Chen Haibo

延年益寿/伯涛写于珠山客次/［朱文方印］"伯涛"
Inscribed with the title, *Yannian yishou*. Artist's signature and square relief seal, "Botao"

This is just the kind of bird-and-flower painting in which Bi Botao excelled. The Chinese name of the paradise flycatchers, *shou dai niao*, in this scene contains a homonym for "longevity" (*chang shou*). In addition, the pine tree also has the meaning of longevity in Chinese symbolism. Hence, this painting has been given a title that means "to extend longevity." [FLL]

8. 程意亭　春风得意图小瓷板
Cheng Yiting (1895-1948)
Uplift in Spring, 1940

Famille-rose porcelain panel
10¼ x 7¼ in. (26 x 18.5 cm)
Collection of Chen Haibo

春风得意/子嘉吾兄雅玩/弟李克敬赠/庚辰冬抚南沙老人法/程意亭写于珠山/［白文方印］"意亭"
Inscribed with the title, *Chunfeng deyi*, and one line indicating that the panel is a gift from Li Ke to his friend Zijia. Date and signature of the artist followed by his square intaglio seal, "Yiting"

Like Bi Botao, Cheng Yiting excelled in this kind of auspicious bird-and-flower painting. In China, the expression "uplift in spring," inscribed here as the title, frequently describes the happy and carefree frame of mind. Therefore, such scenes easily find customers who like the subject and artists willing to paint them. [FLL]

7 | 8

Xu Zhongnan (1872–1953) was born in Nanchang city, Jiangxi. After several years of private school, Xu was sent by his father in 1887 to a decoration workshop (*hong dian*) in Nanchang to work as an apprentice. Afterwards he was employed in Nanchang as a porcelain painter. But in order to improve his skills, Xu Zhongnan went to Jingdezhen. He eventually opened a shop in Hankou, Hubei province, where he painted and sold his own porcelains. Because of the lasting influence of Jingdezhen's artistic circles and his shared interests with such well-known artists as Wang Qi, Xu was invited to take part in the Jingdezhen Ceramic Fine Arts Research Society when it was founded in 1922. Six years later, at the age of fifty-six, he joined the Full Moon Society and became the eldest member of the Eight Friends of Mount Zhu. Xu's works were deeply influenced by the nineteenth-century painter Dai Xi and closely matched his works in composition, strokes, and colors. He was also influenced by the Shanghai painting school and the Southern Song artist Su Dongpo. Ultimately, however, he formed his own style.

9. 徐仲南　雨过溪流图小瓷板
Xu Zhongnan (1872-1953)
Creek after Rain, 1938
Famille-rose porcelain panel
10¼ x 7¼ in. (26 x 18.5 cm)
Collection of Chen Haibo

雨过溪流交响/树凉暑气潜消/不是谢公别墅/定应杜老西郊/戊寅夏五月/徐仲南写于珠山棲碧山馆/［朱文方印］"仲南"

Inscribed with a six-character *shi* poem in four lines, beginning "Creek after rain" (*yuguo xiliu*) and describing the beauty and pleasantness of the scenery after rain. Date and signature followed by the artist's square relief seal, "Zhongnan"

The coloring of this porcelain plaque is characteristic of Xu Zhongnan's work, in which blues and greens dominate the scheme. The square red seal is eye-catching but not showy. In a setting of tall mountains and flowing stream, an old gentleman stands on a bridge. It is a solitary and desolate but quite poetic scene. [FLL]

雨過溪流友鄉音樹涼
暑氣潛消不是謝公
別墅宣庭杜聖西郊
戊寅夏五月徐仲南
寫于珠山樓碧山僬

Tian Hexian (1894–1932), one of the Eight Friends of Mount Zhu, was born in Zhejiang and, as a youth, lived with his father-in-law's family in Jiangxi. Before turning to a career in porcelain painting, he worked in the Jingdezhen Tax Bureau in the early years of the Republic of China and taught in the night school of the Jiangxi Porcelain Company. He specialized in landscape painting and then switched to painting plum blossoms, which gained him a standing in painting circles. He was influenced by the Yuan dynasty artist Wang Mian, especially his compositions and the strokes of his bamboo paintings.

10. 田鶴仙　冬梅图小瓷板
Tian Hexian (1894-1932)
Winter Plum

Famille-rose porcelain panel
10 ¼ x 7 ¼ in. (26 x 18.5 cm)
Collection of Chen Haibo

赋质孤高迥出尘/潇然空有与谁邻/西湖结得林和靖/千古清风更绝伦/仿元人煮石山农之大意/荒园老梅
田鹤仙写于珠山/[朱文方印]"鹤仙"

Inscribed with a seven-character *shi* poem praising the elegance and aloofness of winter plum. Signature of the artist followed by his square relief seal, "Hexian"

The plum is a favorite tree among the Chinese people because it blossoms in the cold of winter and in the snow. Tian Hexian's plum blossoms here occupy a steep angle in the composition; the turns in the brush strokes have strength. Thus, the proud erect spirit of the tree is vividly evinced. [FLL]

賦質孤高廻出塵墨池空去寄詩人
疎雨湖桥浔林初珮于琚清風更
絶倫倣元人畫石山林袋之大・爰
荒園芝梅田崔山尝于珠山

Born in Yugan county, Jiangxi, **Deng Bishan** (1874–1930), was a scholar at the end of the Qing dynasty and had taught privately in his hometown. But after the imperial examination system was abolished in 1911, Deng went to teach in the Raozhou (now Poyang county) Ceramics School (later called the Jiangxi Ceramic School) and there tried his hand at painting ceramics. Two years later he went to Jingdezhen, where he began to paint for a living—first by writing on ceramics and then by painting portraits. It was Deng who initiated portrait painting on ceramics at Jingdezhen. His celebrity portraits won first prize in national craft exhibitions. After the age of forty, Deng specialized in painting fish and water plants and also painted flower-and bird themes. In these subjects, he was influenced by Japanese painting, Song painting, as well as by the more recent Lingnan painting school. In 1928, at the age of fifty-four, he joined the Full Moon Society and became the earliest and briefest member of the Eight Friends of Mount Zhu.

11. 邓碧珊　鱼乐图小瓷板
Deng Bishan (1874-1930)
The Happiness of Fish, 1929
Famille-rose porcelain panel
10¼ x 7¼ in. (26 x 18.5 cm)
Collection of Chen Haibo

山外斜阳半未沉/清潭一鉴绿阴阴/此时我也知鱼乐/不是雷同庄子心/已巳春月/铁肩子邓碧珊画于珠山/
[白文方印]"邓氏"
Inscribed with a seven-character *shi* poem describing the happy fish in a pond at sunset. Date and signature followed by a square intaglio seal, "Dengshi"

This painting is a representative work by Deng Bishan. It reveals the influence of Japanese painting in his application of color. In addition, his brush technique and compositional structure show the influence of Song academic painting. [FLL]

He Xuren (1882–1940) was born in Nanling county, Anhui. As a youth, he learned cobalt-blue decorating in Jingdezhen and then turned to *famille-rose* decorating. In the first year of the Republic of China, he began learning how to archaize porcelain under the employment of the brothers Zhan Yuanguang and Zhan Yuanbin. His skill was greatly improved by this training and by emulating the famous paintings of antiquity and the ceramics preserved in the Imperial Palace. He specialized in *famille-rose* depictions of snow-covered landscapes and, in addition, became good at microscopic engraving. In his middle age, He Xuren commuted frequently between Jingdezhen and Jiujiang in Jiangxi, where he had set up shop to paint and sell his own works. One of the Eight Friends of Mount Zhu, He influenced generations of famous ceramic painters. His snow-covered landscape painting became a traditional pattern of Jingdezhen ceramic decoration handed down to this day.

12. 何许人　踏雪寻梅图小瓷板
He Xuren (1882-1940)
Walking in Snow to Seek Plum Blossoms, 1934
Famille-rose porcelain panel
10¼ x 7¼ in. (26 x 18.5 cm)
Collection of Chen Haibo

踏雪寻梅/时在甲戌季冬月/许人何处画于湓浦/［朱方方印］"何"
Inscribed with the title, *Taxue xunmei.* Date and signature of the artist, followed by his square relief seal, "He"

The snow scene here is yet another allusion to a classical Chinese story. In the depth of winter, during the twelfth month, the Tang dynasty poet Meng Haoran would become philosophical. When the plum blossoms were beginning to open, he would brave the snow and ride out on a donkey to search for plum trees. This reflects the emotional appeal of the refined scholar laboring at poetry while appreciating scenery. [FLL]

Wang Bu (1898–1968) was born in Fengcheng county, Jiangxi. He acquired a love of painting from his father, Wang Xiuqing, who was an excellent cobalt-blue decorator during the Tongzhi and Guangxu eras in the Qing dynasty. At the age of nine, Wang Bu began to study with the Jingdezhen cobalt-blue artist Xu Yousheng and finished his apprenticeship in 1912. When the workshop went out of business, Wang became homeless and had to earn a living by painting bird feeder jars. Later, he was employed by the ceramic master Wu Aisheng to make archaistic ceramics. Imitating exquisite imperial porcelains day and night gave Wang a foundation for future innovation. After Wu died, Wang stopped making archaistic ceramics. He creatively employed the traditional technique of the "iron-wire line" in his cobalt-blue decoration, producing elegant and fresh-looking pieces. His works shed the conventionality and stereotypes of late Qing ceramic painting. The slump in the ceramic industry caused by the war with Japan obliged Wang to give up cobalt blue and turn to overglaze color decorating. After the founding of New China, Wang was able to return to painting with cobalt blue.

13. 王步　青花花鸟小瓶一对
Wang Bu (1898-1968)
Pair of Vases with Bird-and-Flower Painting, 1920s-30s
Porcelain with underglaze cobalt blue
Height 9⁷⁄₁₆ in. (24 cm) each
Collection of Chen Haibo

Painted in underglaze cobalt blue on each of these small vases is a pair of wild geese flying in and out of the reeds. They are lively and meticulously painted. To master to perfection the concentration of color in blue-and-white decoration, the artist not only must have excellent painting skills but also excellent skill in the craft of cobalt-painting; for most people, this is difficult to achieve. [FLL]

14. 王步　青花笔筒
Wang Bu (1898-1968)
Brush Pot, 1963
Four-character mark on base: *Jingdezhen zhi*
Porcelain with underglaze cobalt blue
Height 6⁵⁄₁₆ in. (16 cm)
Collection of Chen Haibo

追琢他山石/方圆一勺深/抱才唯守墨/求用每虚心/波浪因文起/尘埃为废侵/凭君更研究/何啻值千金/竹溪/[朱文方印]"王步"

Inscribed with a five-character *shi* poem describing how to behave as a literatus. Date and signature of the artist, followed by a cobalt-blue square relief seal, "Wang Bu"

This square brush pot, which is decorated in the *xieyi* (spontaneous) brush manner, is a work of Wang Bu's later years. On the one hand, his eyesight in his later years did not permit works in his meticulous *gongbi* brush manner. On the other hand, the large *xieyi* manner perhaps added a greater sketchiness and uninhibited carefreeness. [FLL]

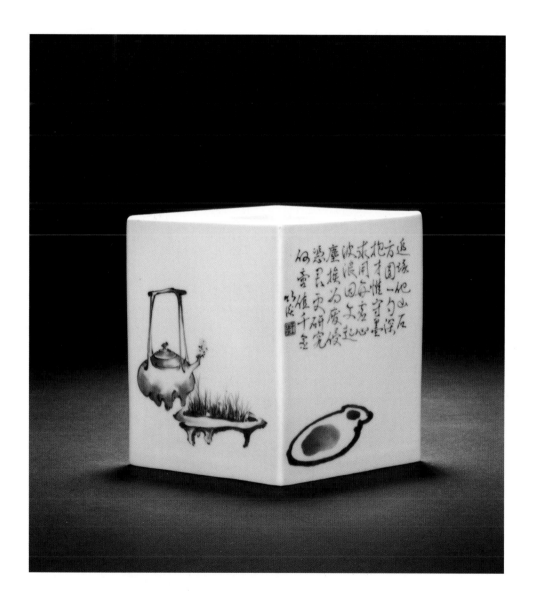

Wang Xiliang (1922–) was born in Jingdezhen, but his ancestral home was in Anhui. He specialized in landscape and portrait painting. His early mentor in ceramic painting was his uncle Wang Dafan (one of the Eight Friends of Mount Zhu). In 1954, he entered the Ceramic Industry Scientific Research Institute of the Ministry of Light Industry to study ceramic art. Five years later, in 1959, he was among the first painters to be awarded the title of "ceramic artist," and in 1979 he was the first person in Jingdezhen to be honored with the title of "Chinese Art and Crafts Master." In his middle age, Wang reformed his artistic approach by traveling widely and sketching from nature (see cat. no. 16).

15. 王锡良　七月七日长生殿插盘
Wang Xiliang (b. 1922)
Double Seventh at the Palace of Eternal Life, 2006
Famille-rose porcelain plate
Diam. 7⅞ in. (20 cm)
Collection of Chen Haibo

七月七日长生殿/夜半无人私语时/丙戌夏日/王锡良写于珠山/[朱文方印]"王印"
Inscribed with the title *Qiyue qiri Changshengdian*. Date and artist's signature, followed by his square relief seal, "Wang yin"

The Palace of Eternal Life is an imperial garden on the outskirts of Chang'an, the Tang dynasty capital. From there a beautiful love story was spread. It was in this place, on the night of the seventh day of the seventh month, that Emperor Xuanzong and Yang Guifei together swore an oath to Heaven, pledging their love with a gold hairpin and an inlaid box. This is the very scene depicted in the painting. Wang Xiliang carried on the tradition of the Eight Friends of Mount Zhu; for the most part his paintings concern classic tales and legends. [FLL]

16. 王锡良　瓷瓶
Wang Xiliang (b. 1922)
Vase, 1985
Porcelain with underglaze red and blue and celadon glaze
14 x 3 ¾ in. (35.5 cm x 9.5 cm)
Collection of Chen Haibo

游遍峨嵋与九嶷／无兹殊胜幻迷zz离／任他五岳归来客／一见黄山也称奇／乙丑秋日／写于建国瓷厂王锡良／
［朱文圆印］"王"

Inscribed with a seven-character *shi* poem praising the magnificent Huangshan (Yellow Mountain). Signature of the artist who made this vase at the Jiangxi Porcelain Factory, followed by the artist's circular relief seal, "Wang"

Shi Yuren (1928–1996) was born in Yuyao county, Zhejiang. In 1948, he entered the Hangzhou National Art Academy, which became the Huadong branch of the Central Academy of Fine Arts. In 1952, he transferred to the Department of Sculpture in the Central Academy of Fine Arts, Beijing. After graduating in 1954, Shi stayed in the research center of the Central Academy for further study. In 1955, when the Ceramic Art Skill School was founded in Jingdezhen, he was assigned to teach there by the National Higher Education Ministry. Three years later, in 1958, he participated in the founding of the Jingdezhen Ceramic Institute and became a professor there. Shi had a great passion for ceramic folk art and research into overglaze enamel wares.

17. 施于人　小鸟供石五彩瓷盘
Shi Yuren (1928-1996)
Scholar-Rock and Bird Plate
Porcelain decorated with red and green overglaze enamel
Diam. 6 in. (15 cm)
Private collection

于人／[朱文方印]"作"
Signed "Yuren"; square relief seal, "zuo"

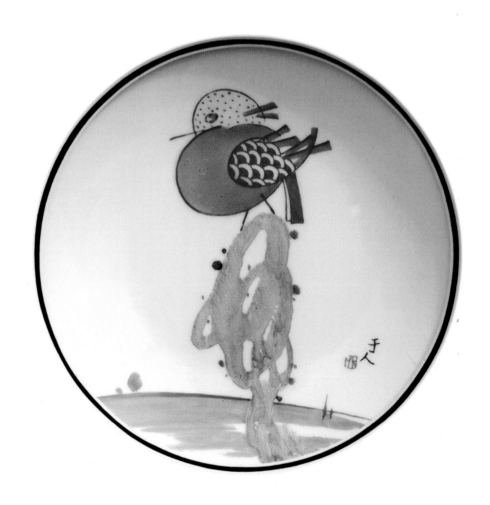

18. 施于人　小鸟供石五彩瓷盘
Shi Yuren (1928-1996)
Scholar-Rock and Bird Plate
Porcelain decorated with red and green overglaze enamel
Diam. 6 in. (15 cm)
Private collection

于人/［朱文方印］"作"
Signed "Yuren"; square relief seal, "zuo"

These two red-and-green plates were painted in Shi Yuren's later years. While the red-and-green palette created by him used traditional colors and techniques, his works have a strong decorative quality and exhibit a modern sensibility. [FLL]

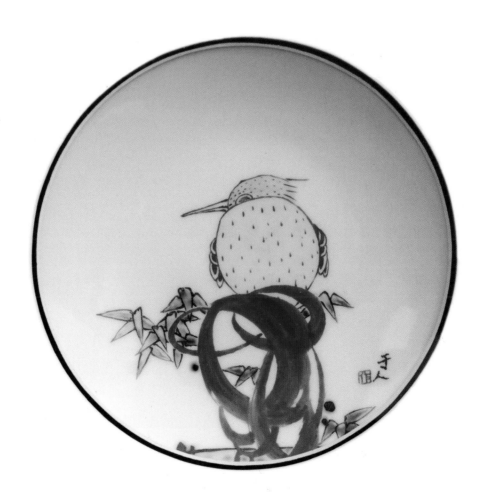

Zhou Guozhen (1931–) was born in Anren county, Hunan. He graduated in 1954 from the Department of Sculpture in the Central Academy of Fine Arts, Beijing, and worked at the Jingdezhen Ceramics Research Center. Currently, a professor at the Jingdezhen Ceramics Institute, he has been dedicated to ceramic education for decades and holds positions in many other institutions: consultant to the Sculpture Committee of the Chinese Arts and Crafts Institute; vice president of the Jiangxi branch of the Chinese Artists Association; president of the Jiangxi Sculpture Association; honorary president of the Jingdezhen Artists Association; and chairman of the board of directors of the Gaoling (Kaolin) Ceramics Association. His early works focused on children and other realistic themes. At that time he was influenced by academic realism, and his style was very different from the traditional sculptural style of Jingdezhen ceramic artists. In his later periods, he created a world of animal figures, such as his *Sacred Water Buffalo* (cat. no. 19), while exploring high-temperature colored glazes and other techniques.

19. 周国桢　圣水牛瓷塑
Zhou Guozhen (b. 1931)
Sacred Water Buffalo, 2009
Unglazed porcelain and slip
10⅛ x 15¾ x 5⅞ in. (26 x 40 x 15 cm)
Collection of Chen Haibo

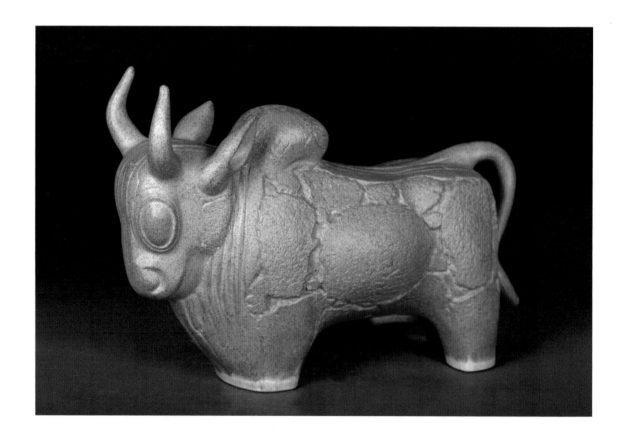

20. 周国桢　猴王瓷塑
Zhou Guozhen (b. 1931)

Monkey King

Unglazed porcelain and slip

11 $^{13}/_{16}$ x 9 $^{13}/_{16}$ x 9 $^{13}/_{16}$ in. (30 x 25 x 25 cm)

Collection of Chen Haibo

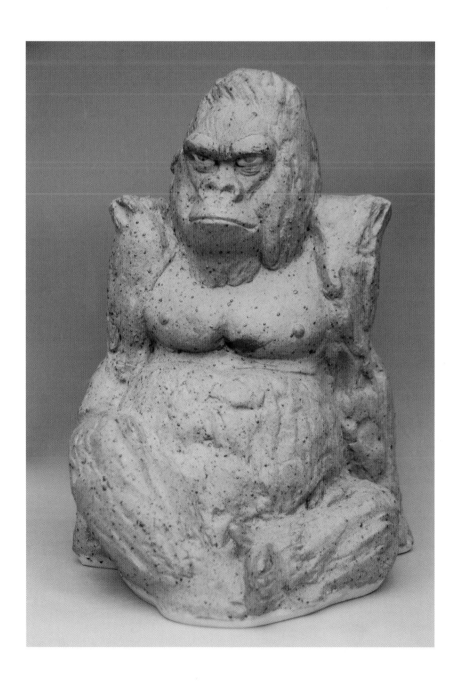

A pioneer in the development of contemporary ceramic sculpture in China, **Yao Yongkang** was born in 1942, in Ningbo city, Zhejiang, and graduated from the Fine Arts Department of Jingdezhen Ceramic Institute in 1966. He is a professor and postgraduate tutor in the Jingdezhen Ceramics Institute, a member of China Artists' Association, director of the sculpture committee of Jiangxi province, and president of the Gaoling (Kaolin) Ceramic Art Association, and he enjoys a special government allowance from the State Council. His ceramic sculpture has been recognized by numerous awards in Chinese and international exhibitions.

21. 姚永康　世纪娃
Yao Yongkang (b. 1942)
Millennium Baby, 2006
Celadon-glazed porcelain
14½ x 9 x 8 in. (36.8 x 22.9 x 20.3 cm)
Collection of Beatrice Chang

Part of a series that he began in 1997, this sculpture embodies the artist's hopes for the birth of a new human spirit in the new millennium. The child is sheltered by a lotus leaf, a Buddhist symbol of purity, and sits on a dog-like creature associated with protection in Chinese mythology. [NS]

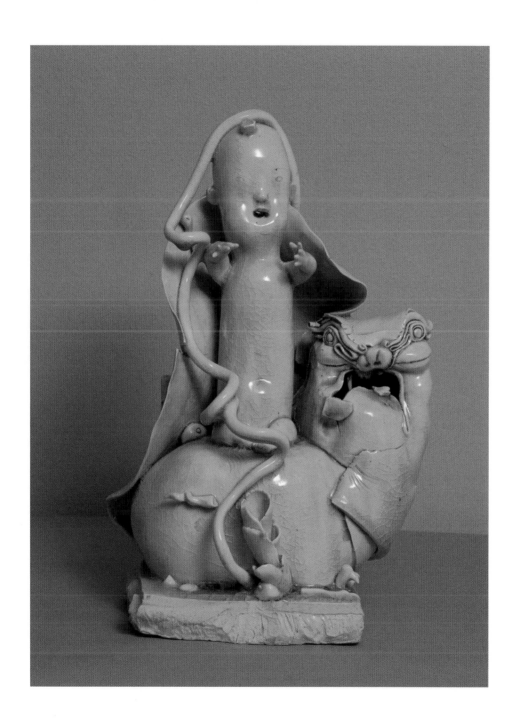

Born in Jingdezhen in 1952, **Zhu Legeng** is the son of a porcelain artist. He attended Jingdezhen Ceramics Institute, receiving his MA in 1988. Upon graduation, he remained at the Institute as a professor and was named one of the ten most influential people in Jingdezhen. In 1997, his work was displayed at a solo exhibition in Beijing, held by China Art Gallery in conjunction with the Jingdezhen Ceramics Institute. That same year, he established the Jingdezhen Folk Kiln Art Institute and the Zhu Legeng Ceramics Studio. In 2008 he was elected Deputy President of the China Arts and Crafts Association. His works have been collected and exhibited widely in China, Japan, South Korea, France, Germany, the United States, and Canada. Currently, he is director of the Ceramics Research Center and a professor of ceramics at the Chinese National Academy of Arts in Beijing.

22. 朱乐耕　禅意
Zhu Legeng (b. 1952)
Zen, also titled *Lotus Figures*, 2011

Porcelain with white glaze and gold luster

Dimensions vary: each figure, H. approx. 50 in. (128 cm)

Collection of the artist

This work consists of a very large group of figures, from which these five were selected for exhibition. Zhu Legeng considers his *Nirvana* a companion piece to this sculpture. While *Zen* represents the inner strength and core of the Buddhist practice, *Nirvana* represents the void through which life is renewed. [NS]

23. 朱乐耕　涅槃
Zhu Legeng (b. 1952)
Nirvana, 2012
111 porcelain fragments with white glaze and gold luster
Dimensions of pieces vary: smallest, 1 ³/₁₆ x 2 in. (3 x 5 cm); largest, 13 x 4⁹/₁₆ in. (33 x 4 cm)
Installation varies
Collection of the artist

This mural installation features a collection of isolated figurative gestures and lotus elements associated with Buddhist iconography. Six heads are receptive, empty vessels dispersed into a void along with disembodied blossoms, hands, stems, arms, leaves, and seed pods. The elements are arranged as if they were an ancient sign language. [NS]

24. 朱乐耕　天马
Zhu Legeng (b. 1952)
Heavenly Horse, 2008
Yingqing (shadow-blue) porcelain
4 ½ x 30 x 8 ½ in. (11.4 x 76.2 x 21.6 cm)
Collection of James J. Chin

A thick coating of *yingqing* glaze unites the solitary horse with a wide-open landscape. Zhu Legeng's expert control of this glaze exploits the expressive qualities of its water-like fluidity. [NS]

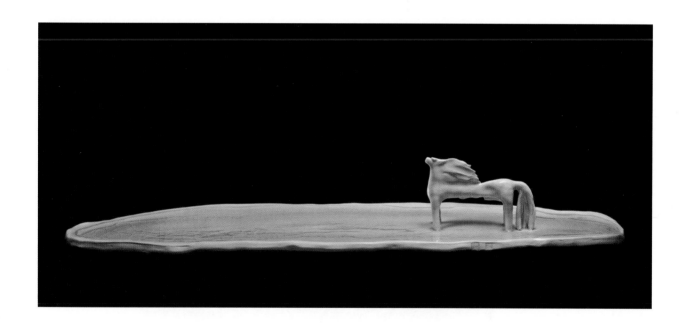

Caroline Yi Cheng (Zheng Yi) was born in Cambridge, UK, in 1963. She studied fine arts at Michigan State University and received her MA in sculpture from the Academy of Art College, San Francisco, in 1988. Since assuming the directorship of Hong Kong's Pottery Workshop in 1997, she has rapidly expanded this educational program by establishing new facilities in Shanghai (2002), Jingdezhen (2004), and Beijing (2007). The Workshop's classes, residencies, exhibitions, and lectures serve the local communities and attract hundreds of international artists and students. Cheng is also a lecturer at Shanghai's Fudan University. During the past two decades she has had seven solo and over fifty group exhibitions in Hong Kong, Shanghai, Beijing, Paris, and the United States.

25. 郑祎　福
Caroline Yi Cheng (b. 1963)
Prosperity, 2012
Unglazed porcelain and jute/cotton fabric
24 ½ x 70 ¼ x 1 in. (9.6 x 178.4 x 2.5 cm)
Collection of Beatrice Chang

Individual butterflies, all unique and different, are unified in a dense composition on the fabric of this hanging garment. Its title in Chinese, *Fu*, is a homonym for "clothing." By commissioning thousands of small porcelain butterflies for her recent dress sculptures, Caroline Cheng features the talent of Jingdezhen's skilled artisans. Her porcelain-laden garments are both reminiscent of and in sharp contrast to the Han dynasty's jade burial suits. Both share a labor intensity and precious material weight that elevate them far beyond the realm of fashion into the categories of ceremony and symbolic performance. [NS]

Detail

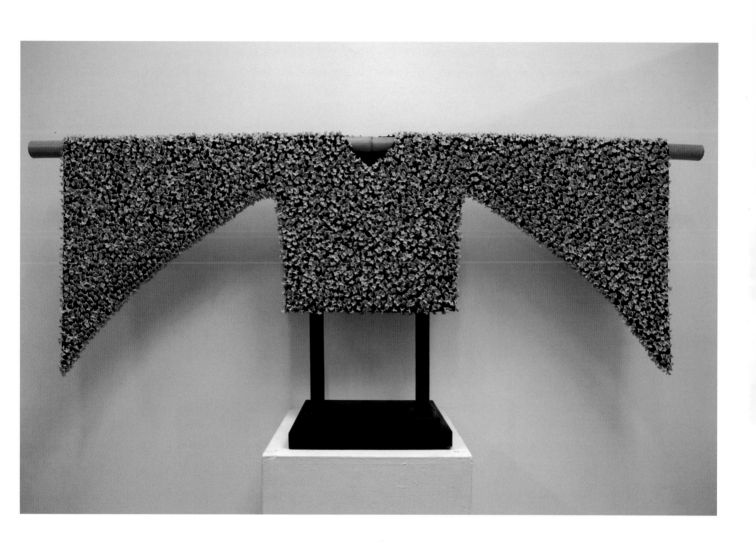

Sin-ying Ho (Sin Ying Cassandra Ho) was born in Hong Kong in 1963 and studied ceramics at the Nova Scotia College of Art and Design (BFA), Louisiana State University (MFA), and the Jingdezhen Ceramics Institute in China. She is currently an associate professor in the Art Department of Queens College, City University of New York. Her work has been widely exhibited, reviewed, and referenced in art journals and books. Sin-ying Ho uses porcelain as an expressive "touchstone" to examine issues of her cultural identity. In addition to the traditional techniques still practiced in Jingdezhen, she uses new ceramic decorating techniques such as digital decal printing. By combining classical Chinese forms and traditional glaze-painting imagery with cubistic sculptural forms and popular culture icons, she creates work that reflects her multi-national life experience and resonates with the complexity of contemporary global culture.

26. 何善影　英雄系列第2号——卧虎藏龙
Sin-ying Ho (b. 1963)
***Hero*, no. 2—*Crouching Tiger and Hidden Dragon*, 2008**
Glazed porcelain, hand-painted cobalt pigment, computer-printed decal transfer, terra sigillata
13 x 15¾ x 9 in. (33 x 40 x 22.9 cm)
Collection of the artist

Hand-painted designs and photo decal images related to the popular movie *Crouching Tiger, Hidden Dragon* animate the surface of this complex and dynamic sculptural form, one which seems to contain the gestural energy of martial art maneuvers, crouching tigers, and undulating dragons. [NS]

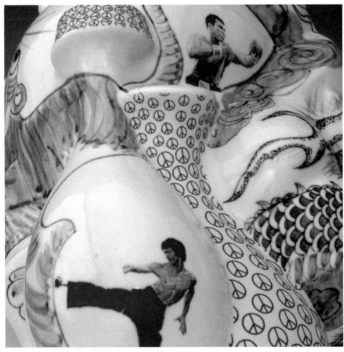

Detail

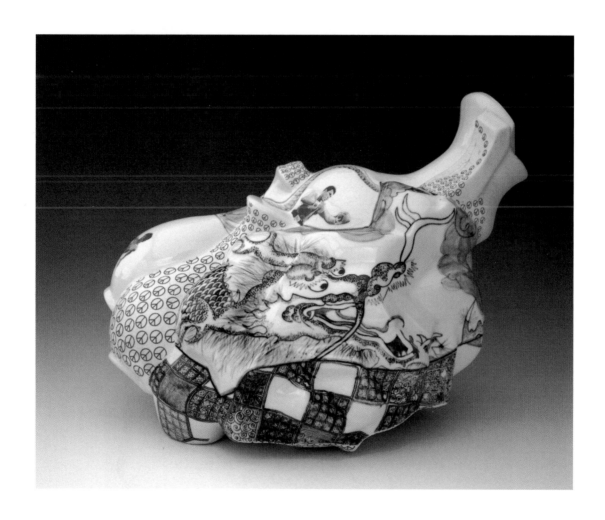

27. 何善影　后现代时代制作系列4号
Sin-ying Ho (b. 1963)
Made in the Postmodern Era, no. 4, 2008
Glazed porcelain, hand-painted cobalt pigment, computer-printed decal transfer, terra sigillata
15 ½ x 11 ¼ x 8 ½ in. (39.4 x 28.6 x 21.6 cm)
Collection of the artist

Photodecals of Chariman Mao, Mona Lisa, and Western pop icons Andy Warhol and Marilyn Monroe are juxtaposed with a traditional blue-and-white dragon painting to cover the faceted surface of these collaged vase forms. Compositional strategies include the modernist precedent of cubism as well as contemporary music and film practices of rapid editing, mixing, and channel surfing. She is tuning in several channels at once to embody her diaspora experience and the complexity of contemporary global culture. [NS]

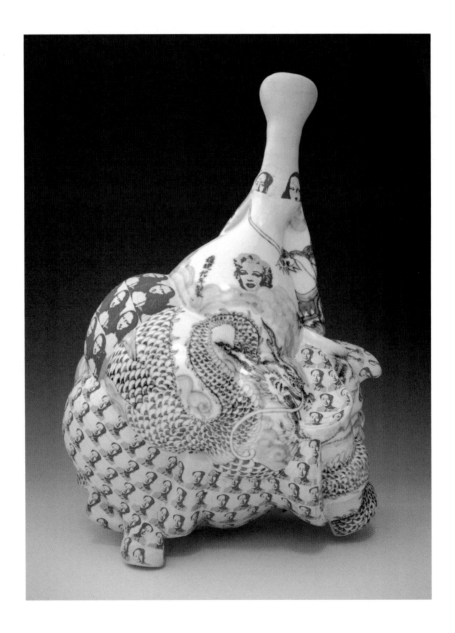

28. 何善影　充满希望的梦想系列2号
Sin-ying Ho (b. 1963)
In the Dream of Hope, no. 2, 2010

Glazed porcelain, hand-painted cobalt pigment,
　　high-fire underglaze decal transfer
69 x 18½ in. (175.3 x 47 cm)
Collection of the artist

Created in the aftermath of the 2008 economic crash, *In the Dream of Hope*, no. 2, features the silhouettes of a seated Adam and a standing Eve, who reaches for fruit in a lush garden. Rows and columns of stock values fractured by a plummeting graph line fill their silhouettes. Sin-ying describes this series of vessels:†

Images of consumerism and traces of technology juxtaposed with Edenic imagery on the life-size vessels create a visual metaphor for the relationship between human nature and the changing physical world. New meets old, technology confronts tradition, language opposes communication, aesthetic ideals face cultural identity, and economy accosts power in a stunning garden that evokes the collisions of 21st-century globalization.

† Sin-ying Ho, artist's statement e-mailed to the author, March 21, 2012.

[NS]

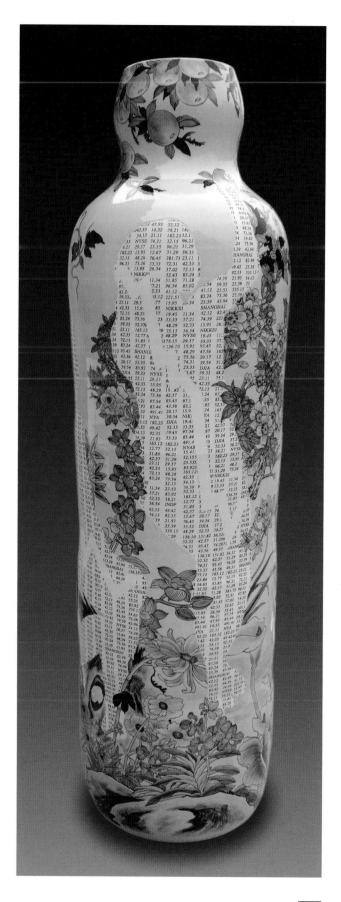

Lu Bin was born in Beijing in 1961. He graduated from Nanjing Art Institute in 1988 and became director of the ceramics program of Shenzhen Sculpture Academy in 1998. Since 2002, he has been the director and associate professor of ceramics at the Nanjing Art Institute. Most recently, his work was included in the First Guangdong Contemporary Ceramics Art Exhibition in 2007 and the Guangdong Contemporary Sculpture Exhibition in 2008, both at the Guangzhou Art Museum.

29. 陆斌　化石 2004 III
Lu Bin (b. 1961)
Fossil 2004 III, 2004
Five porcelain objects (glazed and unglazed)
Dimensions vary: smallest, 10 ⅟₁₆ x 4 ⅛ x 3 ⅛ in. (23 x 12 x 8 cm);
　largest, 11 ⁷⁄₁₆ x 5 ⅛ x 3 ¹⁵⁄₁₆ in. (29 x 13 x 10 cm)
Collection of the artist

During the past decade in his *Fossil* series, Lu Bin has concentrated on the fundamental nature of ceramics as a medium of cultural preservation. In *Fossil 2004 III* he has excavated beyond the façade and into the core of traditional porcelain vessels to discover evidence of war, environmental degradation, Eastern religious architecture, and Western consumer products. [NS]

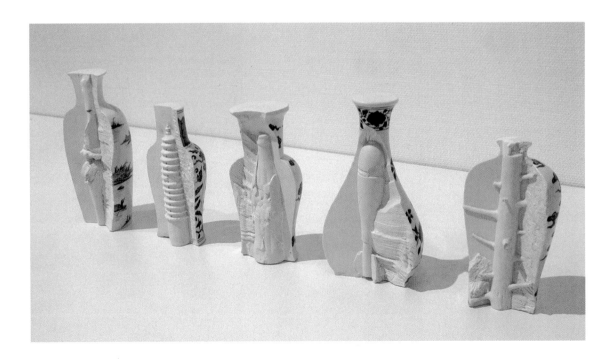

30. 陆斌　大悲咒 1, 4, 3
Lu Bin (b. 1961)
Great Compassion Mantra 1, 4, 3, 2012

Video (DVD, 8 min.), porcelain fragments of three vases
Original dimensions of each vase: 16⅛ x 9¹³⁄₁₆ in. (42 x 25 cm)
Installation varies
Collection of the artist

Observing the time-lapse disintegration of blue-and-white porcelain vases while listening to a Buddhist chant of the Great Compassion Mantra is a meditation on tradition, time, and transformation. Each scene in the video records the gradual destruction of three different works (separately subtitled *1*, *4*, and *3*)—a stupa, these vases, and handscrolls. According to the artist, they represent broken beliefs in the concepts of faith, life, and civilization respectively. [NS]

 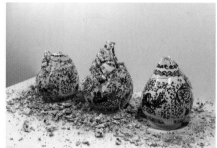 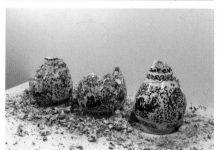

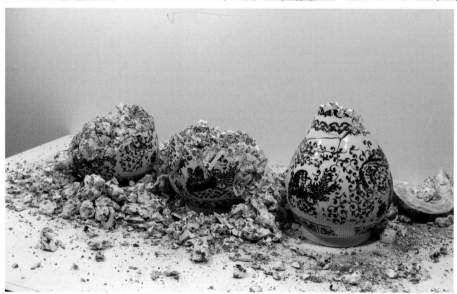

Zhao Meng was born in 1967 in Anhui province. He studied in the Ceramics Department of the China National Academy of Fine Arts (China Academy of Art), Hangzhou, from 1988 to 1992, and moved to the United States in 2002. From 2006 to 2010, Zhao worked as a resident artist and teacher in the Ceramics Program at Harvard University, Cambridge, Massachusetts. Currently, he is creating sculpture at his studio in Jingdezhen and coordinating the development of a new International Ceramics Center in Hangzhou. His work has been recognized by many finalist awards in international exhibitions and by the 2003 Gold Medal in the 53rd International Competition of Contemporary Ceramics, Faenza, Italy. Zhao Meng's sculptures explore the cultural significance of Chinese scholar's rocks through a contemporary use of porcelain.

31. 赵梦　河流的记忆
Zhao Meng (b. 1967)
The Memory of the River, 2008
Glazed porcelain
24 x 11 x 11 in. (61 x 27.9 x 27.9 cm)
Collection of Mee-Seen Loong

Here, the artist simulates geological processes to create the eroding forms of his ceramic scholar's rocks. [NS]

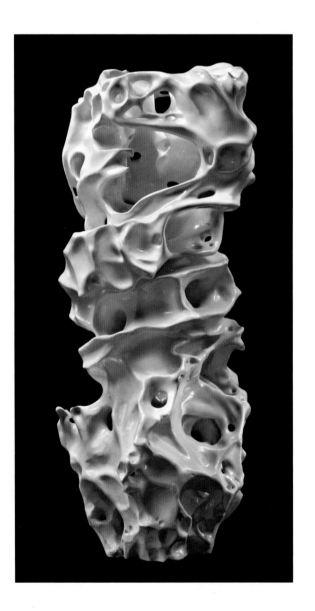

32. 赵梦　水的印象
Zhao Meng (b. 1967)
The Impression of Water, 2008
Glazed porcelain
16 x 5 ½ x 8 ½ in. (40.6 x 14 x 21.6 cm)
Collection of Mee-Seen Loong

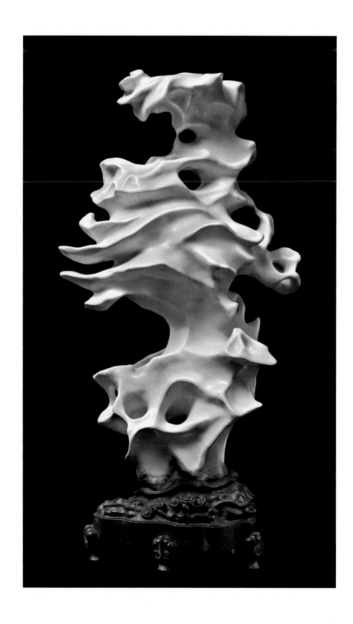

33. 赵梦　青瓷供石
Zhao Meng (b. 1967)
Scholar's Rock (*Gongshi*), 2011
Celadon-glazed porcelain
9 x 5 x 4 in. (22.9 x 12.7 x 10.2 cm)
Collection of Mee-Seen Loong

Zhao Meng merges the reverence for rocks, porcelain, and celadon in Chinese culture in this sculptural porcelain. The scholar's-rock form subtly suggests an anthropomorphic gesture. [NS]

34. 赵梦　青瓷供石
Zhao Meng (b. 1967)
Scholar's Rock (*Gongshi*), 2011
Celadon-glazed porcelain
8 x 5 x 3 in. (20.3 x 12.7 x 7.6 cm)
Collection of Mee-Seen Loong

35. 赵梦　岩岛
Zhao Meng (b. 1967)
Rock Island, 2010
Celadon-glazed porcelain
5 x 6¾ x 3½ in. (12.8 x 17.2 x 8.9 cm)
Collection of Mee-Seen Loong

This brush rest captures the rugged power of an island landscape, providing inspiration to the scholar-painter. [NS]

36. 赵梦　水波浪
Zhao Meng (b. 1967)
Cresting Waves, 2010
Celadon-glazed porcelain
2¾ x 8¼ x 2¾ in. (7 x 21 x 7 cm)
Collection of Mee-Seen Loong

This brush rest, in the shape of a seascape, inspires the user with the dynamic energy of nature. [NS]

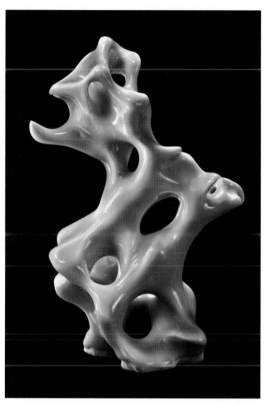

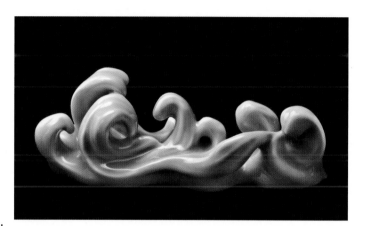

33	36
35 | 34

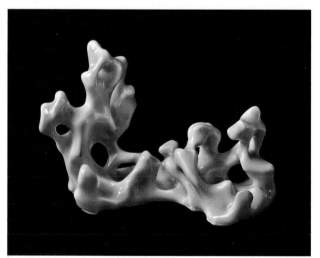

Born in Anhui's Xiao county, **Zhu Dequn** (1920– ; Chu Teh-Chun) entered the Hangzhou National Art Academy in 1935 to learn Western painting and graduated in 1941. He had taught in the Department of Architecture in Nanjing Central University (1945), the Department of Art in Taipei Normal University (1949), and Taiwan Normal College (1951–55). Then, in 1955, he moved to Paris and in 1980 became a naturalized French citizen. He has continued to paint and exhibit internationally, becoming famous in contemporary art as an overseas Chinese artist. In 1997, he was inducted into the Institut de France as a lifetime fellow of its Academy of Fine Arts. When Zhu approached the age of ninety, he created a series of fifty-seven ceramic art works at The Manufacture Nationale de Sèvres in France. Working on a vase form (SR22) developed at the manufactory, he recorded his painterly vision of a world he described as "of snow, gold, and blue sky." Decorated mainly in Sèvres blue, these works reflect his ties to Chinese culture. His works in the exhibition (cat. nos. 37–39) add specks and splashes of gold as well as bright color to the dynamic, swiftly drawn lines and shapes in blue. Although abstract, the paintings evoke the imagery of classic Song and Yuan dynasty painting.

37. 朱德群　瓷瓶
Zhu Dequn (b. 1920)

Vase, 2007

On the base: Artist's vermillion seal; blue Sèvres mark; and series title, *De neige, d'or et d'azur/ Of Snow, Gold, and Blue Sky*; and the red imprint of the gilding and decoration mark
Porcelain painted in cobalt blue with highlights in gold
15 ¾ x 11 ¹³⁄₁₆ in. (40 x 30 cm)
Collection of Manufacture de Sèvres, France

画乃自我画，书乃自我书。

When it comes to painting, I paint what comes from myself; when it comes to calligraphy, I write what comes from myself.

—Zhu Dequn†

† Jean-Paul Desroches, *Of Snow, Gold, and Sky Blue: Ceramic Works by Chu Teh-Chun* (Paris: Éditions de La Martinière groupe, 2009), pp. 124–25.

38. 朱德群　瓷瓶
Zhu Dequn (b. 1920)

Vase, 2007

On the base: Artist's vermillion seal; blue Sèvres mark; and series title, *De neige, d'or et d'azur* / *Of Snow, Gold, and Blue Sky*; and the red imprint of the gilding and decoration mark

Porcelain painted in cobalt blue with highlights in gold

15 ¾ x 11 ¹³⁄₁₆ in. (40 x 30 cm)

Collection of Manufacture de Sèvres, France

远望之以取其势，近看之以取其质。

By studying the subject from a distance, you grasp its lines of force; by studying it close up, you grasp its substance.

—*Zhu Dequn*†

† Desroches, *Of Snow, Gold, and Sky Blue*, pp. 146–47.

39. 朱德群　瓷瓶
Zhu Dequn (b. 1920)
Vase, 2007

On the base: Artist's vermillion seal; blue Sèvres mark; and series title, *De neige, d'or et d'azur /*
Of Snow, Gold, and Blue Sky; and the red imprint of the gilding and decoration mark
Porcelain painted in cobalt blue with highlights in gold
15 ¾ x 11 ¹³⁄₁₆ in. (40 x 30 cm)
Private collection, Hong Kong

有一种画，初入眼时，粗服乱头，不守绳墨，细视之则气韵生动，寻味无穷。

There is a kind of painting that, at first sight, seems to be raw, meaningless chaos, but on closer look is full
of mental rhythms, revealing the presence of inexhaustible delights.

　　　　　　　　　　　　　　　　　　　　　　　—*Zhu Dequn*†

† Desroches, *Of Snow, Gold, and Sky Blue*, pp. 188–89.

40. 朱德群　瓷瓶
Zhu Dequn (b. 1920)
Vase, 2007
On the base: Artist's vermillion seal; blue Sèvres mark; and series title, *De neige, d'or et d'azur* /
Of Snow, Gold, and Blue Sky; and the red imprint of the gilding and decoration mark
Porcelain painted in cobalt blue with pink, yellow, and brown colors and highlights in gold
15 ¾ x 11 ¹³⁄₁₆ in. (40 x 30 cm)
Private collection, Hong Kong

笔锋下决出生活。
Let life arise and persist from the tip of a brush.

— *Zhu Dequn*†

† Desroches, *Of Snow, Gold, and Sky Blue*, p. 202.

[FLL]

Wayne Higby was born in Colorado Springs, Colorado, in 1943. He received his MFA from the University of Michigan, Ann Arbor, in 1968 and has been on the faculty of the New York State College of Ceramics at Alfred University in Alfred, New York, since 1973. Currently, he is also a faculty member of the Central Academy of Fine Arts, Beijing, and vice president of the International Academy of Ceramics, Geneva, Switzerland. His artistic achievements were recognized by the American Craft Movement Visionary Award, received from the American Craft Museum in 1995. Numerous art museums around the world have collected his work. Since 1991, Higby has pioneered exchanges between artists in China and the USA. He has been named Honorary Professor of Art at Shanghai University and Honorary Professor of Ceramic Art at the Jingdezhen Ceramic Institute. In 2004 he became the first foreign national to be acclaimed an Honorary Citizen of Jingdezhen, the Porcelain Capital of China.

41. 文铁山　土云草绘 / 黄金3号
Wayne Higby (b. 1943)
EarthCloud Sketch / Gold #3, 2012
Celadon-glazed, hand-cut porcelain; gold luster
15¾ x 27 x 7 in. (40 x 68.6 x 17.8 cm)
Collection of the artist

42. 文铁山　土云草绘 / **4号**
Wayne Higby (b. 1943)
EarthCloud Sketch / #4, **2012**
Celadon-glazed, hand-cut porcelain
15 ¾ x 27 x 7 in. (40 x 68.6 x 17.8 cm)
Collection of the artist

These are studies for Wayne Higby's large mural (30 x 56 ft.) *EarthCloud*, installed in Alfred University's Miller Performing Arts Center. The mural fuses the tactile physicality and fractured geology of raw porcelain with the illusion of a vast landscape. [NS]

43. 文铁山　包伟湖的回忆——十月雨
Wayne Higby (b. 1943)
Lake Powell Memory—October Rain, 1999
Celadon-glazed porcelain
16 ½ x 20 ½ x 12 ½ in. (41.9 x 52.1 x 31.8 cm)
Collection of the Everson Museum of Art, Syracuse, New York

It is difficult to distinguish his subtle low-relief drawing in this work from natural fissure lines in the clay or crackle lines in the glaze. Intent, substance, and process are merged into one. [NS]

Born in 1960 in Beijing, **Ah Xian** has lived in Australia since 1990. In the course of investigating his own heritage, Ah Xian works with traditional Chinese artisans to explore the expressive possibilities of various craft materials and techniques in a contemporary context. The porcelain studies that he began in Sydney in the early 1990s prepared him for his pioneering work in Jingdezhen. The resulting *China, China* series—"self-portrait" porcelain busts—has had an enormous impact on contemporary ceramic sculpture. His work has been widely exhibited and honored by the National Gallery of Australia's inaugural National Sculpture Prize in 2001 and the National Gallery of Victoria's Clemenger Contemporary Art Award in 2009.

44. 阿仙　**China, China**——胸像35
Ah Xian (b. 1960)
China, China—Bust 35, 1999
Porcelain with underglaze cobalt blue
13 ⅜ x 15 ⁹⁄₁₆ x 8 ¹¹⁄₁₆ in. (34 x 39.5 x 22 cm)
Collection of the artist

The traditional flower-and-bird design painted on this porcelain bust includes a strong vine that wraps tightly around the neck and frames a shield-shaped opening on the chest. Here, Ah Xian uses porcelain as a "touchstone" for expressing and examining cultural identity. To create his *China, China* series he worked with the skilled technical support of Jingdezhen's traditional artisans to cover a Western classical sculptural form, the bust, with Chinese landscape painting or decorative motifs. He says, "If I had not come to Australia I would not have had the idea. It was only after a few years in Australia that I had a better perspective on China."†

† Artist's statement from *Life-casting.com*, accessed June 29, 2012,
 http://www.artmolds.com/ali/halloffame/ah_xian.htm.

[NS]

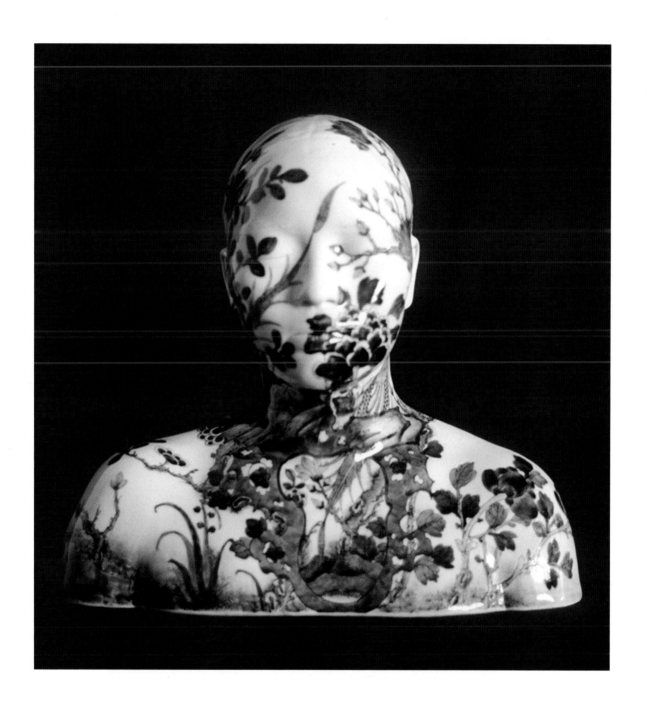

45. 阿仙　China, China——胸像45
Ah Xian (b. 1960)
China, China—Bust 45, 1999
Porcelain with *jiaohuang* enamel glaze
13 ¾ x 17 ⁵⁄₁₆ x 9 ¹³⁄₁₆ in. (35 x 44 x 25 cm)
Collection of the artist

The glazed surface of this male porcelain bust is carved in relief with an ocean wave design. [NS]

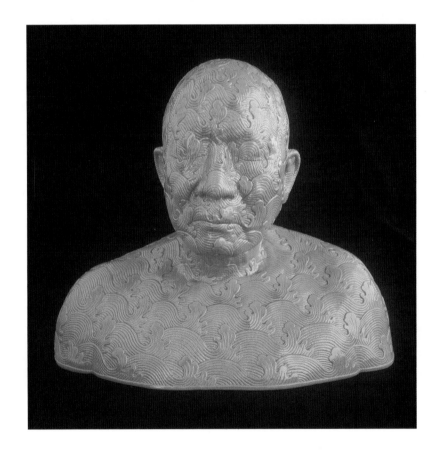

46. 阿仙　China, China——胸像60
Ah Xian (b. 1960)
***China, China—Bust 60*, 2002**
Porcelain with overglaze silver finish
16⅛ x 16⅛ x 8¹¹⁄₁₆ in. (41 x 41 x 22 cm)
Collection of the artist

This female porcelain bust is carved with an openwork "Ten Thousand Flowers" design. Floral forms are strategically positioned to suggest parts of the human anatomy. The stark contrast between the flower-covered body and the realistically modeled ears adds a mysterious dimension to this passive but alert figure. The metallic quality of the finish prefigures Ah Xian's work with traditional artisans in other media: cloisonné, lacquer, and bronze. [NS]

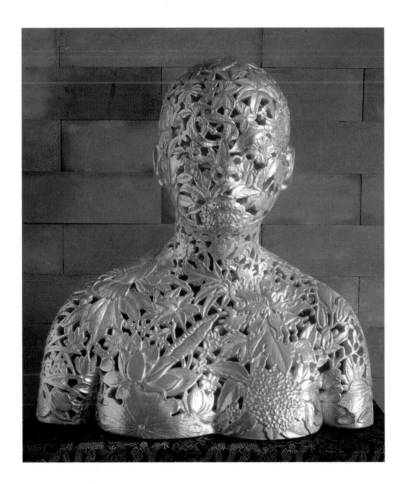

47. 阿仙　China, China——胸像65
Ah Xian (b. 1960)
China, China—Bust 65, 2002
Porcelain and overglaze polychrome enamels
15⁹⁄₁₆ x 15¾ x 9¹³⁄₁₆ in. (39.5 x 40 x 25 cm)
Collection of the artist

This bust is painted in overglaze enamels with a landscape scene. The lower part of the torso is earthbound and cloaked in a hilly terrain. The pure white dome of the head rises above the highest mountain peaks. The placement of this traditional landscape on a still figure with closed eyes suggests the state of mind attained through Buddhist meditation. [NS]

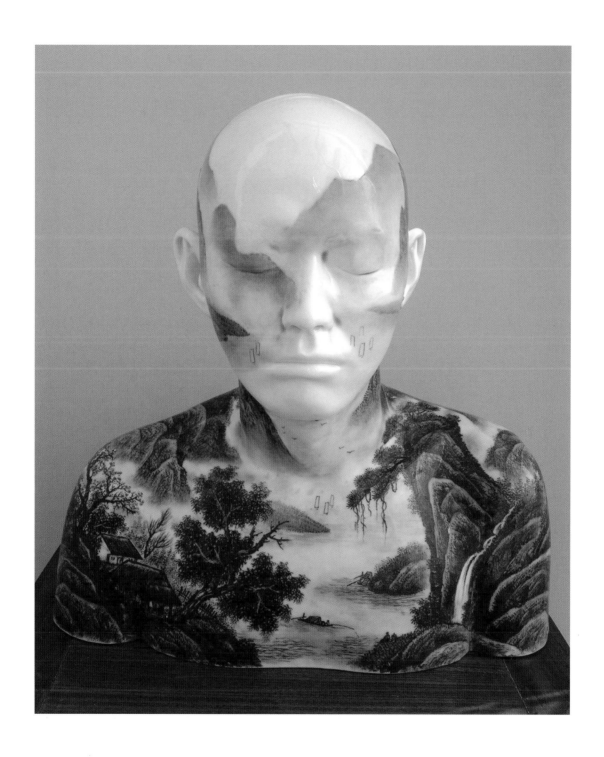

SELECTED CHINESE CHARACTERS
For names and terms used in the text

beipiao	北漂	*Jiangxi tongzhi*	江西通志	Qianlong	乾隆	Xinping	新平
Anren	安仁	Jianwen	建文	Qimen	祁门	Xiuning	休宁
Bo Ya	伯牙	Jiaqing	嘉庆	*qin*	琴	Xiyu	西玉
Boyang	波阳	*jiayuqi*	假玉器	*qingbai*	青白	Xu Yousheng	许友生
Chang (River)	昌江	*Jingde nian zhi*	景德年制	*qinghua*	青花	Xuande	宣德
chang shou	长寿	Jingdezhen	景德镇	*qinghua wang*	青花王	Xuantong	宣统
Chang'an	长安	*Jingdezhen taolu*	景德镇陶录	Raozhou	饶州	Xuanye	玄烨
Changnan	昌南	*jingpiao*	景漂	Ren Bonian	任伯年	Xuanzong	玄宗
Cheng Yaosheng	程瑶笙	Jingtai	景泰	Renren	人人	Yang Guifei	杨贵妃
Chongzhen	崇祯	Jiujiang	九江	Sanbao	三宝	Yeting	野亭
Dai Xi	戴熙	*Jurentang zhi*	居仁堂制	She (county)	歙县	*yingqing*	影青
Dongxiang,	东乡	Kangxi	康熙	Shen Zhenhua	孙振华	Yingzong	英宗
fencai	粉彩	*kuang cao*	狂草	*shi*	诗	Yiyang	弋阳
Fengcheng	丰城	Lang Tingji	郎廷极	Shi Tao	石涛	Yongzheng	雍正
fu (clothing)	服	*langjicao*	狼鸡草	*shou dai niao*	绶带鸟	Yuan Shikai	袁世凯
Fu (prosperity)	福	*Langyao qi*	郎窑器	*shufu*	枢府	Yueyuan hui	月圆会
Fudan	复旦	Leping	乐平	Shunzhi	顺治	Yugan	余干
Fuliang	浮梁	Letian taoshe	乐天陶社	Su Dongpo	蘇東坡	Yuqichang	御器厂
Fuliangxian zhi	浮梁县志	Li Hongzhang	李鸿章	Taiping	太平	Yuyao	余姚
Gaoling	高岭	Li Ke	李克	Tang Ying	唐英	Yuyao chang	御窑厂
gongbi	工笔	Li Renzheng	李仁政	Tangyao qi	唐窑器	Zang Yingxuan	臧应选
Gongshi	供石	*linglongshi*	玲珑石	Taomi	陶迷	*Zangyao qi*	臧窑器
Guangxu	光绪	Lingnan	岭南	*Taoyao*	陶窑	Zhan Yuanbin	詹元斌
Guangzhou	广州	Liu Jinhua	刘建华	Tianjin	天津	Zhan Yuanguang	詹元广
guanyao	官窑	*Liushui mingqin*	流水鸣琴	Tianshun	天顺	Zhang Xiaogeng	张晓耕
hanfu	汉服	Lizexuan	丽泽轩	Tongzhi	同治	Zhang Yunshan	张云山
Hangzhou	杭州	Longquan	龍泉	Wang Chunchen	王春辰	Zhang Zhidong	张之洞
Hankou	汉口	Lu Pinchang	吕品昌	Wang Mian	王冕	Zhao Heng	赵恒
hong dian	红店	Machang	麻仓	Wang Shimao	王世懋	Zheng He	郑和
Hongwu	洪武	Meng Haoran	孟浩然	Wang Xiaotang	汪晓棠	Zhengtong	正统
Hongxi	洪熙	Nanchang	南昌	Wang Xiuqing	王秀青	Zhenzong	真宗
Hua Yan	华嵒	Nanjing	南京	Wanli	万历	Zhizheng	至正
Huadong	华东	Nanling	南陵	Wannian	万年	Zhong Ziqi	钟子期
Huangshan	黄山	Nian Xiyao	年希尧	Weibo	微博	Zhongguo tao	
Huguang	湖广	*Nianyao qi*	年窑器	Wu Aisheng	吴霭生	xuetang	中国陶业学堂
Huoyao	霍窑	Ningbo	宁波	Wu Sangui	吴三桂	Zhu Di	朱棣
Jiajing	嘉靖	Nü Wa	女娲	Wuyuan	婺源	Zhu Yan	朱琰
Jiangxi ciye		Pan Taoyu	潘陶宇	*xiandai taoyi*	现代陶艺	Zhushan bayou	珠山八友
gongsi	江西瓷业公司	Pingshan Caotang	平山草堂	Xianfeng	咸丰	Zijia	子嘉
Jiangxi sheng		Poyang	鄱阳	*xieyi*	写意		
wenshi guan	江西省文史馆	Pufangju	普芳居	Xingzi	星子		

BIBLIOGRAPHY

Chang, Willow Weilan Hai. *Spirit Rock, Sacred Mountain: A Chinese View of Nature*. Exhibition catalogue. New York: JYoung Art, 2011.

Cotter, Holland. "'China Refigured'—The Art of Ah Xian With Selections From the Rockefeller Collection." *The New York Times*, November 08, 2002.

Duan, Lian. "Western Influences on Contemporary Chinese Art Education: Two Case Studies of Responses from Chinese Academics and College Students to Modern Western Art Theory." PhD thesis, Concordia University, 2012.

Emerson, Julie, Jennifer Chen, and Mimi Gardner Gates. *Porcelain Stories: From China to Europe*. Seattle and London: Seattle Art Museum in association with University of Washington Press, 2000.

Fang Lili. *Jingdezhen minyao*. Beijing: Renmin chubanshe, 2003.

Fuliangxian zhi 浮梁县志 [Gazetteer of Fuliang county]. China: n. p., Qianlong 48th year [1783].

Jingdezhen shi zhilue bianzuan weiyuanhui 景德镇市志编纂委员会编, ed. *Jingdezhen shi zhilue* 景德镇市志略 [*Records of Jingdezhen city*]. Shanghai: Hanyu da cidian chubanshe, 1989.

Kanazawa Yoh. "The Export and Trade of Chinese Ceramics: an Overview of the History and Scholarship to Date." In Li Zhiyan et al., *Chinese Ceramics*, pp. 535–63.

Kerr, Rose and Nigel Wood. *Ceramic Technology*. Vol. 5, pt. 12 of *Science and Civilisation in China* by Joseph Needham. With additional contributions by Ts'ai Mei-Fen and Zhang Fukang. Cambridge: University Press, 2004.

Kingery, W. David and Pamela B. Vandiver. *Ceramic Masterpieces: Art, Structure, and Technology*. New York: Free Press, 1986.

Li Zhiyan, Virginia L. Bower, and He Li, eds. *Chinese Ceramics from the Paleolithic Period through the Qing Dynasty*. New Haven and London: Yale University Press, 2010.

Peng Yuxin 彭雨新 et al., ed. *Zhongguo fengjian shehuijingji shi* 中国封建社会经济史 [History of China's feudal society]. Wuhan: Wuhan daxue chubanse, 1994.

Sargent, William R. "The Significance of Exports and Trade During the Later Dynasties." In Li Zhiyan et al., *Chinese Ceramics*, pp. 569–601.

Wang Shimao 王世懋. *Eryou weitan* 二酉委譚. *Juan* 206 in *Jilu huibian* 纪录汇编 [Compilation of Records]. Shanghai: Shanghai Commercial Press, 1938.

Yao Yongkang 姚永康. *Shiji wa* 世紀娃 [Millennium baby]. Shijiazhuang shi: Hebei meishu chubanshe, 2002.

Zhu Legeng 朱乐耕. *Collection of Ceramic Art Works of Zhu Legeng: Environment/Art/Clay*. Beijing: Culture and Art Publishing House, 2009.

INDEX OF ARTISTS IN THE EXHIBITION

CHINA INSTITUTE GALLERY EXHIBITIONS: 1966-2012

1. SELECTIONS OF CHINESE ART FROM PRIVATE COLLECTIONS IN THE METROPOLITAN AREA
November 15, 1966–February 15, 1967
Curator: Mrs. Gilbert Katz

2. ART STYLES OF ANCIENT SHANG
April 5–June 11, 1967
Curator: Jean Young

3. ANIMALS AND BIRDS IN CHINESE ART
October 25, 1967–January 28, 1968
Curator: Fong Chow

4. GARDENS IN CHINESE ART
March 21–May 26, 1968
Curator: Wan-go H.C. Weng

5. CHINESE JADE THROUGH THE CENTURIES
October 24, 1968–January 26, 1969
Curator: Joan M. Hartman

6. FOREIGNERS IN ANCIENT CHINESE ART
March 27–May 25, 1969
Curator: Ezekiel Schloss

7. CHINESE PAINTED ENAMELS
October 23, 1969–February 1, 1970
Curator: J.A. Lloyd Hyde

8. ALBUM LEAVES FROM THE SUNG AND YUAN DYNASTIES
March 26–May 30, 1970
Curator: C.C. Wang

9. MING PORCELAINS: A RETROSPECTIVE
October 29, 1970–January 31, 1971
Curator: Suzanne G. Valenstein

10. CHINESE SILK TAPESTRY: K'O-SSU
March 24–May 27, 1971
Curator: Jean Mailey

11. EARLY CHINESE GOLD AND SILVER
October 21, 1971–January 30, 1972
Curator: Dr. Paul Singer

12. DRAGONS IN CHINESE ART
March 23–May 28, 1972
Curator: Hugo Munsterberg

13. WINTRY FORESTS, OLD TREES: SOME LANDSCAPE THEMES IN CHINESE PAINTING
October 26, 1972–January 28, 1973
Curator: Richard Barnhart

14. CERAMICS IN THE LIAO DYNASTY: NORTH AND SOUTH OF THE GREAT WALL
March 15–May 28, 1973
Curator: Yutaka Mino

15. CHINA TRADE PORCELAIN: A STUDY IN DOUBLE REFLECTIONS
October 25, 1973–January 27, 1974
Curator: Claire le Corbeiller

16. TANTRIC BUDDHIST ART
March 14–May 24, 1974
Curator: Eleanor Olson

17. FRIENDS OF WEN CHENG-MING: A VIEW FROM THE CRAWFORD COLLECTION
October 24, 1974–January 26, 1975
Curators: Marc F. Wilson and Kwan S. Wong

18. ANCIENT CHINESE JADES FROM THE BUFFALO MUSEUM OF SCIENCE
April 3–June 15, 1975
Curator: Joan M. Hartman

19. ART OF THE SIX DYNASTIES: CENTURIES OF CHANGE AND INNOVATION
October 29, 1975–February 1, 1976
Curator: Annette L. Juliano

20. CHINA'S INFLUENCE ON AMERICAN CULTURE IN THE 18TH AND 19TH CENTURIES
April 8–June 13, 1976
Curators: Henry Trubner and William Jay Rathburn
(Exhibition traveled to the Seattle Art Museum, October 7–November 28, 1976)

21. CHINESE FOLK ART IN AMERICAN COLLECTIONS: EARLY 15TH THROUGH 20TH CENTURIES
October 27, 1976–January 30, 1977
Curator: Tseng Yu-Ho Ecke

22. EARLY CHINESE MINIATURES
March 16–May 29, 1977
Curator: Dr. Paul Singer

23. I-HSING WARE
October 28, 1977–January 29, 1978
Curator: Terese Tse Bartholomew
(Exhibition traveled to the Nelson Gallery of Art, Kansas City, February 19–May 21, 1978, and the Asian Art Museum of San Francisco, June 16–September 21, 1978)

24. EMBROIDERY OF IMPERIAL CHINA
March 17–May 28, 1978
Curator: Jean Mailey

25. ORIGINS OF CHINESE CERAMICS
October 25, 1978–January 28, 1979
Curator: Clarence F. Shangraw

26. ART OF THE HAN
March 14–May 27, 1979
Curator: Ezekiel Schloss

27. TREASURES FROM THE METROPOLITAN MUSEUM OF ART
October 25–November 25, 1979
Curator: Clarence F. Shangraw

28. CHINESE ART FROM THE NEWARK MUSEUM
March 19–May 25, 1980
Curators: Valrae Reynolds and Yen Fen Pei

29. CHINESE PORCELAINS IN EUROPEAN MOUNTS
October 22, 1980–January 25, 1981
Curator: Sir Francis Watson

30. FREEDOM OF CLAY AND BRUSH THROUGH SEVEN CENTURIES IN NORTHERN CHINA: TZ'U-CHOU TYPE WARES 960-1600 A.D.
March 16–May 24, 1981
Curator: Yutaka Mino
(Exhibition originated at Indianapolis Museum of Art)

31. THE ART OF CHINESE KNOTTING
July 29–September 21, 1981
Curator: Hsia-Sheng Chen

32. MASTERPIECES OF SUNG AND YUAN DYNASTY CALLIGRAPHY FROM THE JOHN M. CRAWFORD JR. COLLECTION
October 21, 1981–January 31, 1982
Curator: Kwan S. Wong, assisted by Stephen Addiss
(Exhibition traveled to the Spencer Museum, University of Kansas, March 14–April 18, 1982)

33. THE COMMUNION OF SCHOLARS: CHINESE ART AT YALE
March 20–May 30, 1982
Curator: Mary Gardner Neill
(Exhibition traveled to the Museum of Fine Arts, Houston, June 22–August 22, 1982, and the Yale Art Gallery, New Haven, October 5, 1982–April 17, 1983)

34. CHINA FROM WITHIN
November 4–December 12, 1982
A Smithsonian Institution Travelling Services Exhibition, organized by the International Photography Society in cooperation with the China Exhibition Agency, Beijing, and the Chinese Embassy, Washington, DC

35. BAMBOO CARVING OF CHINA
March 18–May 29, 1983
Curators: Wang Shixiang and Wan-go H.C. Weng
(Exhibition traveled to The Nelson-Atkins Museum of Art, Kansas City, July 24–September 11, 1983, and the Asian Art Museum of San Francisco, October 3, 1983–January 15, 1984)

36. CHINESE CERAMICS OF THE TRANSITIONAL PERIOD: 1620-1683
October 21, 1983–January 29, 1984
Curator: Stephen Little
(Exhibition traveled to the Kimbell Art Museum, Fort Worth, May 26–August 26, 1984)

37. MASTERPIECES OF CHINESE EXPORT PORCELAIN AND RELATED DECORATIVE ARTS FROM THE MOTTAHEDEH COLLECTION
February 10–March 7, 1984
U.S.-China 200 Bicentennial Exhibition, organized by Anita Christy

38. CHINESE TRADITIONAL ARCHITECTURE
April 6–June 10, 1984
Curator: Nancy Shatzman Steinhardt
(Exhibition traveled to Allegheny College, Meadeville, PA, March 28–April 19, 1985; Marlboro College, Marlboro, VT, September 11–October 31, 1985; State University of New York, Binghamton, NY January 7–February 27, 1986)

39. CHINESE RARE BOOKS IN AMERICAN
COLLECTIONS
October 20, 1984–January 29, 1985
Curator: Soren Edgren

40. THE SUMPTUOUS BASKET: CHINESE
LACQUER WITH BASKETRY PANELS
March 20–June 3, 1985
Curator: James C.Y. Watt

41. KERNELS OF ENERGY, BONES OF EARTH: THE
ROCK IN CHINESE ART
October 26, 1985–January 26, 1986
Curator: John Hay

42. PUPPETRY OF CHINA
April 19–June 29, 1986
Curator: Roberta Helmer Stalberg
Organized by the Center for Puppetry Arts, Atlanta

43. SELECTIONS OF CHINESE ART FROM
PRIVATE COLLECTIONS
October 18, 1986–January 4, 1987
Exhibition celebrating the 60th Anniversary
of China Institute and the 20th Anniversary
of China Institute Gallery, organized by
James C.Y. Watt and Annette L. Juliano

44. 1987 NEW YEAR EXHIBITION

45. CHINESE FOLK ART
April 4–May 30, 1987
Curator: Nancy Zeng Berliner

46. RICHLY WOVEN TRADITIONS: COSTUMES OF
THE MIAO OF SOUTHWEST CHINA AND
BEYOND
October 22, 1987–January 4, 1988
Curator: Theresa Reilly

47. 1988 NEW YEAR EXHIBITION
February 4–February 24, 1988

48. RITUAL AND POWER:
JADES OF ANCIENT CHINA
April 23–June 19, 1988
Curator: Elizabeth Childs-Johnson

49. STORIES FROM CHINA'S PAST
September 17–November 12, 1988
Organized by The Chinese Culture Center
of San Francisco

50. 1989 NEW YEAR EXHIBITION: LANTERNS
January 28–February 25, 1989

51. MIND LANDSCAPES:
THE PAINTINGS OF C.C. WANG
April 3–May 27, 1989
Curator: Jerome Silbergeld

52. CHINA BETWEEN REVOLUTIONS:
PHOTOGRAPHY BY SIDNEY D. GAMBLE,
1917–1927
June 29–September 9, 1989
Organized by The Sidney D. Gamble
Foundation for China Studies and China
Institute in America

53. VIEWS FROM JADE TERRACE: CHINESE
WOMEN ARTISTS, 1300–1912
October 5–December 2, 1989
Organized by Indianapolis Museum of Art

54. 1990 NEW YEAR EXHIBITION:
THE CHINESE EARTH–VIEWS OF NATURE
January–March 1990
Curator: Anita Christy

55. CLEAR AS CRYSTAL, RED AS FLAME:
LATER CHINESE GLASS
April 21–June 16, 1990
Curator: Claudia Brown and Donald Rabiner

56. THE ECCENTRIC PAINTERS OF YANGZHOU
October 20 December 15, 1990
Curator: Vito Giacalone

57. 1991 NEW YEAR EXHIBITION: CHILDREN IN
CHINESE ART
January 26–March 2, 1991
Organized under the auspices of the China
Institute Women's Association

58. ANCIENT CHINESE BRONZE ART: CASTING
THE PRECIOUS SACRAL VESSEL
April 20–June 15, 1991
Curator: W. Thomas Chase

59. EARLY CHINESE CERAMICS FROM NEW
YORK STATE MUSEUMS
October 19–December 14, 1991
Curator: Martie W. Young

60. TREASURES OF THE LAST EMPEROR:
SELECTIONS FROM THE PALACE MUSEUM,
BEIJING
February 1–March 7, 1992
Curator: Lawrence Wu

61. LAMAS, PRINCES AND BRIGANDS:
PHOTOGRAPHS BY JOSEPH ROCK OF THE
TIBETAN BORDERLANDS OF CHINA
April 15–July 31, 1992
Curator: Michael Aris

62. WORD AS IMAGE: THE ART OF CHINESE
SEAL ENGRAVING
October 21–December 12, 1992
Curator: Jason C. Kuo

63. A YEAR OF GOOD FORTUNE–1993:
LEGENDS OF THE ROOSTER AND
TRADITIONS OF THE CHINESE NEW YEAR
January 19–March 6, 1993
Curator: Willow Weilan Hai

64. DISCARDING THE BRUSH: GAO QIPEI,
1660–1734
April 17–June 12, 1993
Curator: Klass Ruitenbeek
Organized by the Rijksmuseum Amsterdam

65. AS YOU WISH: SYMBOL AND MEANING
ON CHINESE PORCELAINS FROM THE TAFT
MUSEUM
October 23–January 15, 1994
Curator: David T. Johnson

66. SENDING AWAY THE OLD,
WELCOMING THE NEW
February 5–March 5, 1994
Curator: Karen Kane

67. CAPTURING A WORLD: CHINA AND ITS
PEOPLE—PHOTOGRAPHY BY JOHN
THOMSON
March 26–June 11, 1994
Organized by the British Council; catalogue
by the British Council

68. AT THE DRAGON COURT: CHINESE
EMBROIDERED MANDARIN SQUARES
FROM THE SCHUYLER V.R. CAMMANN
COLLECTION
October 20–December 22, 1994
Brochure from similar show which took place
at Yale Univ. Art Gallery
Curator: John Finlay

69. ANIMALS OF THE CHINESE ZODIAC:
CELEBRATING CHINESE NEW YEAR
January 20–March 4, 1995
Curator: Willow Weilan Hai

70. CHINESE PORCELAINS OF THE
SEVENTEENTH CENTURY: LANDSCAPES,
SCHOLARS' MOTIFS AND NARRATIVES
April 22–August 5, 1995
Curator: Julia B. Curtis

71. ABSTRACTION AND EXPRESSION IN
CHINESE CALLIGRAPHY
October 14–December 21, 1995
Curator: H. Christopher Luce
(Exhibition traveled to the Seattle Art Museum,
Seattle, Washington, November 21,
1996–March 23, 1997 and to
the Santa Barbara Museum of Art, Santa
Barbara, California, September 18–
November 21, 1999)

72. CALLIGRAPHY AS LIVING ART: SELECTIONS
FROM THE JILL SACKLER CHINESE
CALLIGRAPHY COMPETITION
February 3–March 9, 1996
Curator: Willow Weilan Hai, in conjunction
with the Arthur M. Sackler Foundation,
Washington, D.C.

73. HARE'S FUR, TORTOISESHELL AND
PARTRIDGE FEATHERS: CHINESE BROWN-
AND BLACK-GLAZED CERAMICS,
400–1400
April 20–July 6, 1996
Curator: Robert Mowry
Organized by the Harvard University Art
Museum, Massachusetts

*74. THE LIFE OF A PATRON: ZHOU LIANGGONG
(1612-1672) AND THE PAINTERS OF
SEVENTEENTH–CENTURY CHINA
October 23–December 21, 1996
Curator: Hongnam Kim

75. ADORNMENT FOR ETERNITY: STATUS AND
RANK IN CHINESE ORNAMENT
February 6–July 14, 1997
Curators: Julia White and Emma Bunker
Organized by the Denver Art Museum

*76. POWER AND VIRTUE: THE HORSE
IN CHINESE ART
September 11–December 13, 1997
Curator: Robert E. Harrist, Jr.

77. SCENT OF INK: THE ROY AND MARILYN
PAPP COLLECTION OF CHINESE ART
February 5–June 20, 1998
Curator: Claudia Brown
Organized by the Phoenix Art Museum

78. CHINESE SNUFF BOTTLES FROM THE PAMELA
R. LESSING FRIEDMAN COLLECTION
September 16–December 13, 1998
Organized by the Asian Art Coordinating Council

*79. A LITERATI LIFE IN THE TWENTIETH
CENTURY: WANG FANGYU—ARTIST,
SCHOLAR, CONNOISSEUR
February 11–June 20, 1999
Curator: H. Christopher Luce

*80. THE RESONANCE OF THE QIN IN
EAST ASIAN ART
September 16–December 12, 1999
Curator: Stephen Addiss

81. 2000 NEW YEAR EXHIBITION:
THE STORY OF RED
January 12–February 11, 2000
Curator: Willow Weilan Hai Chang

*82. DAWN OF THE YELLOW EARTH: ANCIENT
CHINESE CERAMICS FROM
THE MEIYINTANG COLLECTION
March 21–June 18, 2000
Curator: Regina Krahl
(Exhibition traveled to the Fresno Metropolitan
Museum of Art, Fresno, California, August
11–November 12, 2000)

* 83. THE CHINESE PAINTER AS POET
September 14–December 10, 2000
Curator: Jonathan Chaves

84. LIVING HERITAGE: VERNACULAR
ENVIRONMENT IN CHINA
January 25–June 10, 2001
Curator: Kai-yin Lo

*85. EXQUISITE MOMENTS: WEST LAKE &
SOUTHERN SONG ART
September 25–December 9, 2001
Curator: Hui-shu Lee

86. CIRCLES OF REFLECTION: THE CARTER
COLLECTION OF CHINESE BRONZE
MIRRORS
February 7–June 2, 2002
Curator: Ju-hsi Chou

*87. BLANC DE CHINE:
DIVINE IMAGES IN PORCELAIN
September 19–December 7, 2002
Curator: John Ayer

88. WEAVING CHINA'S PAST: THE AMY S. CLAQUE
COLLECTION OF CHINESE TEXTILES
January 29–June 7, 2003
Curator: Claudia Brown

*89. PASSION FOR THE MOUNTAINS: 17TH
CENTURY LANDSCAPE PAINTINGS FROM
THE NANJING MUSEUM
September 18–December 20, 2003
Curator: Willow Weilan Hai Chang

90. GOLD & JADE: IMPERIAL JEWELRY
OF THE MING DYNASTY FROM THE
NANJING MUNICIPAL MUSEUM
February 12–June 5, 2004
Organized by Nanjing Municipal Museum &
the China Institute Gallery

91. THE SCHOLAR AS COLLECTOR: CHINESE
ART AT YALE
September 23–December 11, 2004
Curator: David Ake Sensabaugh

*92. PROVIDING FOR THE AFTERLIFE:
"BRILLIANT ARTIFACTS" FROM
SHANDONG
February 3–June 4, 2005
Curators: Susan L. Beningson & Carry Liu

93. MASTERPIECES OF CHINESE LACQUER
FROM THE MIKE HEALY COLLECTION
September 16–December 3, 2005
Curator: Julia M. White
Organized by the Honolulu Academy of Arts

*94. TRADE TASTE & TRANSFORMATION:
JINGDEZHEN PORCELAIN FOR JAPAN,
1620–1645
February 2–June 10, 2006
Curator: Julia B. Curtis
(Exhibition traveled to the Honolulu
Academy of Arts, Hawaii, July 19–
October 8, 2006)

95. THE BEAUTY OF CHINESE GARDENS
June 28–August 12, 2006
Organized by the China Institute Gallery

*96. SHU: REINVENTING BOOKS IN
CONTEMPORARY CHINESE ART
Part I: September 28–November 11, 2006
Part II: December 13–February 24, 2007
Curator: Wu Hung
(Exhibition traveled to Seattle Asian Art
Museum, Washington, August 9–December 2,
2007, and Honolulu Academy of Arts, Hawaii,
June 25–August 31, 2008)

97. TEA, WINE AND POETRY: THE ART OF
DRINKING VESSELS THE INTERNATIONAL
ASIAN ART FAIR, NEW YORK
March 23–March 28, 2007
Organized by the China Institute Gallery

98. TEA, WINE AND POETRY: QING DYNASTY
LITERATI AND THEIR DRINKING VESSELS
March 24–June 16, 2007
Curators: Guo Ruoyu and Soong Shu Kong
Organized by the University Museum and Art
Gallery, The University of Hong Kong

*99. BUDDHIST SCULPTURE FROM CHINA:
SELECTIONS FROM XI'AN BEILIN MUSEUM,
FIFTH THROUGH NINTH
CENTURIES
September 20–December 8, 2007
Curator: Annette L. Juliano

100. ENCHANTED STORIES: CHINESE SHADOW
THEATER IN SHAANXI
January 31–May 11, 2008
Curators: Chen Shanqiao, Li Hongjun,
and Zhao Nong
Organized by China Institute Gallery in
collaboration with Shaanxi Provincial
Art Gallery

101. BEIJING 2008: A PHOTOGRAPHIC
JOURNEY
June 12–August 17, 2008
A special exhibition organized by the China
Institute Gallery and the Beijing Archive Bureau

*102. THE LAST EMPEROR'S COLLECTION:
MASTERPIECES OF PAINTING AND
CALLIGRAPHY FROM THE LIAONING
PROVINCIAL MUSEUM
September 25–December 14, 2008
Curators: Willow Weilan Hai Chang,
Yang Renkai, and David Ake Sensabaugh

103. NOBLE TOMBS AT MAWANGDUI: ART AND
LIFE IN THE CHANGSHA KINGDOM, THIRD
CENTURY BCE TO FIRST CENTURY CE
February 12–June 7, 2009
Curator: Chen Jianming
Organized by China Institute Gallery
and Hunan Provincial Museum
(Exhibition traveled to Santa Barbara Museum
of Art, September 19–December 13, 2009)

*104. HUMANISM IN CHINA:
A CONTEMPORARY RECORD
OF PHOTOGRAPHY
September 24–December 13, 2009
Organized by the Guangdong
Museum of Art.
Re-organized by China Institute Gallery and
Jerome Silbergeld.

*105. CONFUCIUS: HIS LIFE AND LEGACY IN ART
February 11–June 13, 2010
Curators: Lu Wensheng and Julia K. Murray
Organized under the direction of Willow
Weilan Hai Chang in collaboration with the
Shandong Provincial Museum

106. WOODCUTS IN MODERN CHINA,
1937–2008: TOWARDS A UNIVERSAL
PICTORIAL LANGUAGE
September 16–December 5, 2010
Exhibition organized by the Picker
Art Gallery at Colgate University

*107. ALONG THE YANGZI RIVER: REGIONAL
CULTURE OF THE BRONZE AGE FROM
HUNAN
January 27–June 12, 2011
Curators: Chen Jianming, Jay Xu, and
Fu Juliang
Organized under the direction of Willow
Weilan Hai Chang in collaboration with
the Hunan Provincial Museum
(Exhibition traveled to Bowdoin College
Museum of Art, Bowdoin College, Brunswick,
Maine, September 1, 2011–January 8, 2012)

* 108. BLOOMING IN THE SHADOWS:
UNOFFICIAL CHINESE ART, 1974–1985
September 15–December 11, 2011
Curators: Kuiyi Shen and Julia F. Andrews
Exhibition directed by Willow Weilan
Hai Chang

* 109. THEATER, LIFE, AND THE AFTERLIFE:
TOMB DÉCOR OF THE JIN DYNASTY
FROM SHANXI
February 9–June 17, 2012
Curator: Shi Jinming
Exhibition directed by Willow Weilan
Hai Chang

* Exhibition catalogues currently available for sale.
For information on the availability of these titles and others, please contact China Institute in America at (212) 744-8181.

CHINA INSTITUTE

Gerard M. Meistrell
William N. Raiford
Diane H. Schafer and Jeffrey A. Stein
Martha Sutherland and Barnaby Conrad III
Patricia P. Tang
Shao Fang and Cheryl L. Wang
Yvonne L. C. and Frederick Wong
Denis C. and Kathleen Yang
Laurie and David Ying
Tina Zonars

GALLERY COMMITTEE

Diane H. Schafer, *Chair*
Yvonne L.C. Wong, *Vice-Chair*

Susan L. Beningson
Claudia Brown
James J. Chin
Mary Wadsworth Darby
Jane DeBevoise
Robert E. Harrist, Jr.
Maxwell K. Hearn
Annette L. Juliano
Peter Rupert Lighte
David Ake Sensabaugh
Jerome Silbergeld
Sophia Sheng
Nancy S. Steinhardt
Julie Grimes Waldorf
Marie-Hélène Weill

GALLERY STAFF

Willow Weilan Hai Chang, *Director*
Jennifer Lima, *Registrar and Manager*
Yue Ma, *Art Education Manager*
Eva Wen, *Coordinator*

DOCENTS

Viviane Chen
Janis M. Eltz
Anna Hong
Roberta Nitka
Patricia Reilly
Zhiwei Xiong

VOLUNTEERS

Jackie Handel
Gloria Young

INTERN

Kelly Baltazar
Gregory McAndrews

CONTRIBUTORS

GUEST CURATORS

Fang Lili is Director of the Art Anthropology Research Center of the Chinese National Academy of Arts in Beijing. Jingdezhen is her hometown. She spent her childhood and graduated from high school there; she studied painting and sculpture at the Jingdezhen Ceramics Institute. Afterwards, she studied with renowned scholar Fei Xiaotong at Qinghua University, where she earned her PhD. She then focused her career on art anthropology. Her research and numerous publications have focused on the creative work, culture, and social conditions of Jingdezhen ceramics artists. This research benefits from Fang Lili's personal immersion in the artistic life of Jingdezhen during the dramatic transitions experienced by her generation. Her publication *Zhongguo taoci* (Beijing, 2005) has been recently translated into English (New York and Cambridge, 2011).

Nancy Selvage, an artist and educator, had been the Director of Harvard University's Ceramics Program for three decades. She received a BA in art history from Wellesley College and an MFA in sculpture from the School of the Museum of Fine Arts/Tufts University. She has taught at Massachusetts College of Art, Ewha University in Seoul, School of the Museum of Fine Arts, and the Rhode Island School of Design. She is familiar with Jingdezhen from a China Trade symposia and visiting artist workshops that she produced at Harvard and from her participation in study tours, international ceramic art conferences and exhibitions in China. In 2001 Nancy Selvage convened artists and scholars to study the history and practice of China Trade porcelain through lectures, demonstrations, and collection tours at the Peabody Essex Museum, the Boston Museum of Fine Arts, and Harvard University's Sackler Museum.

GENERAL EDITOR AND PROJECT DIRECTOR

Willow Weilan Hai Chang, Director of China Institute Gallery, was among the first generation of archaeologists trained after the Cultural Revolution. She earned an advanced degree from the prominent Nanjing University and then served as Assistant Professor at Nanjing Normal University. In the United States, she has been engaged in the field of Chinese art history for more than 23 years. Since 1989, Ms. Hai Chang has been involved in nearly sixty exhibitions at China Institute Gallery, as contributor, curator, or organizer. Named the director of the Gallery in 2000, she has broadened the scope of its exhibitions and has introduced a unique Chinese cultural perspective by exhibiting more excavated artifacts and inviting scholars from China. She has partnered with major Chinese museums in such projects as *The Last Emperor's Collection: Masterpieces of Painting and Calligraphy from the Liaoning Provincial Museum, Noble Tombs at Mawangdui: Art and Life in the Changsha Kingdom,* and *Confucius: His Life and Legacy in Art,* among others. Her own scholarly contributions to numerous exhibitions and catalogues, for this Gallery and others, have been acknowledged by art critics and art historians alike. Notably, she wrote the catalogue for *Passion for the Mountains: Seventeenth Century Landscape Paintings from the Nanjing Museum* (2003).

CONSULTING EDITOR

J. May Lee Barrett, a former Director of China Institute Gallery, currently freelances as a lecturer, editor, and journalist specializing in Asian art. She earned a BFA at the Cooper Union in New York. After receiving a degree in Chinese art history from the Institute of Fine Arts, New York University, she has lectured as a visiting or adjunct instructor at Pratt Institute, New York University, and the University of Maryland. She collaborated with curator Tom Chase in the writing of *Ancient Chinese Bronze Art: Casting the Precious Sacral Vessel* (1991); with Fang Jing Pei in *Treasures of the Chinese Scholar* (1997); and with Robert Youngman in *The Youngman Collection: Chinese Jades from Neolithic to Qing* (2008). In addition to editing numerous catalogues for China Institute Gallery, she has edited *New Songs on Ancient Tunes: 19th–20th Century Chinese Paintings and Calligraphy from the Richard Fabian Collection* (2007) and Kathleen Yang's *Through a Chinese Connoisseur's Eye* (2010).